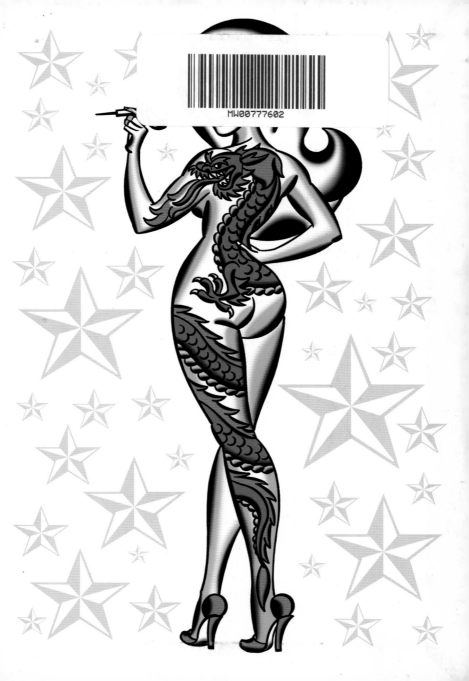

MITCH O'CONNELL TATTOOS

LAST GASP

Published by
Last Gasp of San Francisco
Ronald E. Turner, Publisher
777 Florida Street
San Francisco, CA 94110
www.lastgasp.com

Mitch O'Connell Tattoos
by Mitch O'Connell
ISBN 0-86719-672-6

All text and illustrations: © Mitch O'Connell 2007
Printed in China by Oceanic Graphic Printing

Note to book reviewers: the most insightful (i.e. unabashedly positive) review gets $10.
That's right, you read it correctly. TEN DOLLARS COLD, HARD, AMERICAN CASH
MONEY. Helpful hints include describing the author as, "sinewy, with cat-like reflexes,"
"possessing piercing, sexy blue eyes" and "hot, Hot, HOT!" Heck, I'm all in favor of the
freedom of the press, and I like a good laff, but hurting (me) is always wrong. "Jokers"
shouldn't reuse old, tired lines written by untalented, jealous hacks such as: "sad little man,"
"lives in parents' basement," "prone to rashes," and "uses photographs, a projector and
tracing paper." Include any of those, or something similar, and you can kiss those ten big
ones good-bye. Who'll will be laughing then? It sure as heck won't be you!

Finally, a suggestion. . . Feeling a void in your life? A longing you can't put your finger on?
To see what's missing, put your fingers on the keyboard and visit:

www.mitchoconnell.com

If spending money there doesn't bring you complete bliss, it will at least make me feel a
whole lot better.

To

ILSABE

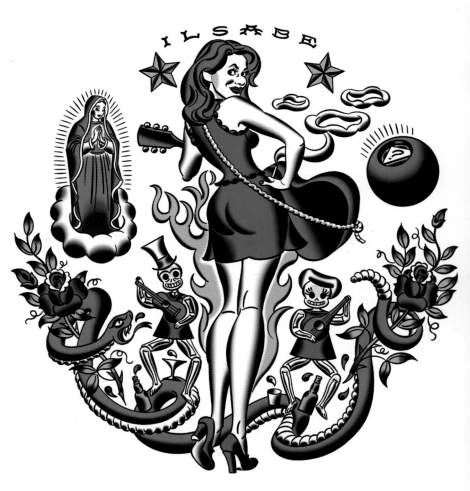

Everything you
always wanted to
know about Mitch*

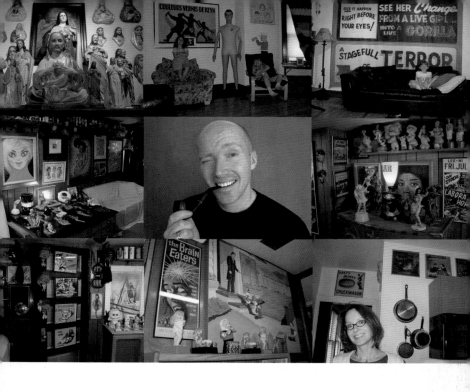

*. . . except that and that and – especially – *that!*

Hello, dear readers! I'd like you to forget those old fashioned introductions where the author decides what you should and shouldn't read. I'm not going to carefully control and spin some test marketed, pre-screened Mitch persona. This intro will be controlled by YOU! YOU ask the questions, YOU decide the topics. Don't like my answer? Think I'm trying to squirm out of an uncomfortable subject? YOU pitch the hardballs!

First question, you, right there, the person with the great taste in books!

HOW DID YOUR INVOLVEMENT WITH DESIGNING FLASH* COME ABOUT?

This is a story not for the faint of heart. Pregnant women, those with heart conditions, and impressionable youth should read no further! The twists and turns of this jaw dropping tale are gonna make you spit teeth! It's as hard hitting as a punch in the gut, yet as tender as a second punch in the gut! In 1999 I was imprisoned for a crime I did not commit. In the joint, I learned to tattoo using shoe leather, paper clips, and spit. To keep the warden from discovering my escape plans, I started to tattoo them directly on my own... I mean, while

*Sheets of paper (usually 11" by 14") containing multiple tattoo designs. They're displayed on the walls of tattoo shops as possibilities for customers to pick from.

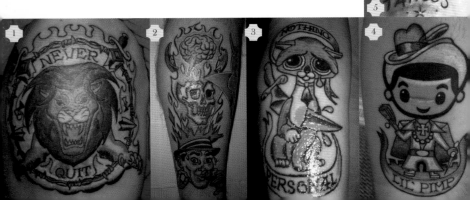

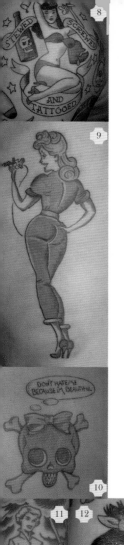

still a toddler I ran away from home and joined a traveling carnival. I lived in a world of cotton candy scams and hoochie-coochie hijinks. From the carnies I picked up the skills to tattoo and was billed as "Tiny Tat, the World's Teeniest Tattooist." Okay, that one is a little exaggerated too. The truth isn't quite as glamorous. I came up with all these doodles while sitting at the drawing table in my 'lil home studio, usually while watching very bad daytime TV.

Years ago I started getting photos from folks who were having my illustrations tattooed on themselves. It floored me. You can't get a much higher compliment than having someone permanently engrave your stuff on their flesh! When I do a drawing for a newspaper, it's thrown out the next day. An illustration for a magazine might stay on the coffee table for a couple of weeks (unless it's at the dentist's office), and a gallery show is only up for a month, but a tattoo... that's gotta be the winner for hanging in there!

I found myself so inspired, I thought I might as well take it one step further and actually do designs that were meant to be tattoos. It was a pleasure and also intimidating to come up with my own. To prepare myself, I spent hours staring down the art of the old school guys, – Sailor Jerry, Dainty Dotty, Owen Jensen, Ralph Johnson, Stoney, Bert Grimm and dozens of others

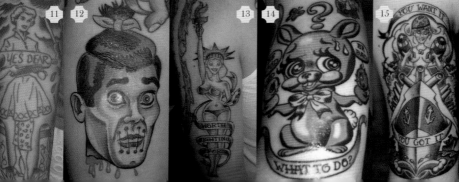

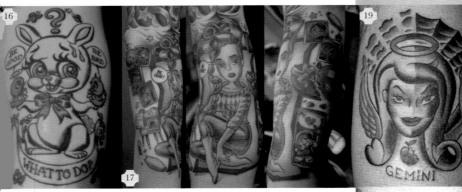

GEMINI

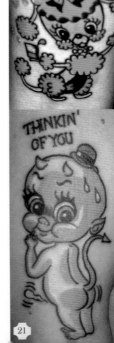

THINKIN' OF YOU

− hoping that some of their skill and wisdom might seep into my skull.

Old school tattoos are something solid and classic, like a hand sewn Revolutionary war flag, a carnival banner or Mount Rushmore. When drawing I try to keep anchored in that tradition. I realized early on that in creating these guides for others to work from, I'd have to adapt my style of drawing so as not to make it a pain in the ass for the people doing the hard part − the tattooists. So, after I drew up the outlines for most of my first set of flash, I pestered every local shop to get some feedback. What makes a design work? What designs bring you the most business? What makes a tattoo easier to do? What happened to my wallet?!!

Since the tattoo community has a history of being a closed shop, I knew that years ago having the chutzpah to think you could draw flash without being a tattooist would have resulted in a back alley chain beating, but since some folks had heard of me and could see that I was sincere, I got a lot of very helpful suggestions. Okay,

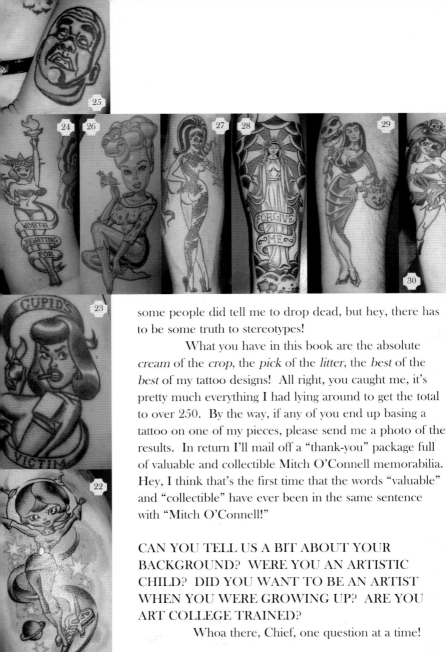

some people did tell me to drop dead, but hey, there has to be some truth to stereotypes!

What you have in this book are the absolute *cream* of the *crop*, the *pick* of the *litter*, the *best* of the *best* of my tattoo designs! All right, you caught me, it's pretty much everything I had lying around to get the total to over 250. By the way, if any of you end up basing a tattoo on one of my pieces, please send me a photo of the results. In return I'll mail off a "thank-you" package full of valuable and collectible Mitch O'Connell memorabilia. Hey, I think that's the first time that the words "valuable" and "collectible" have ever been in the same sentence with "Mitch O'Connell!"

CAN YOU TELL US A BIT ABOUT YOUR BACKGROUND? WERE YOU AN ARTISTIC CHILD? DID YOU WANT TO BE AN ARTIST WHEN YOU WERE GROWING UP? ARE YOU ART COLLEGE TRAINED?

Whoa there, Chief, one question at a time!

9

Yes, besides being a very cute child (according to my mother), I was also a very artistic one. One story goes that at two years of age I did a dead-on portrait of my mom that impressed and awed everyone. Wait a minute... I seem to remember the story originally taking place when I was *five*. It appears I've become more of a child prodigy as the years go by! Now I'm beginning to find all my mom's stories about how wonderful I am suspect.

A career in art was always my only option. It wasn't like I had an abundance of talent in other areas to choose from. So, besides the jobs I had as a teen, all I've done to earn money, or often as not, *not* earn money, has been drawing. I moved to Chicago right after high school to enroll in art school. That means I can draw just fine, but don't attempt to have an intellectual conversation with me. In fact don't even ask me to spell "intellectual." First I signed up at The School of the Art Institute. I spent a year and a half there and then moved across the street to the commercial art oriented American Academy of Art. About midway through my three semesters, I started earning a small income freelancing. Getting busier and busier, and believing I could learn just as much by working, I left school. The rest is art history!

HAVE YOU EVER DONE A TATTOO?

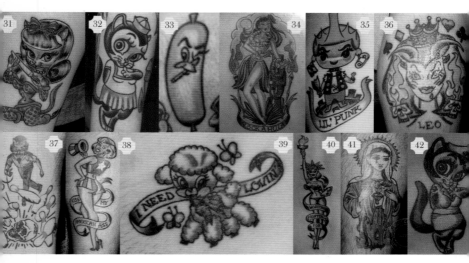

I wouldn't mind giving it a shot, but you have to realize, I do a LOT of erasing when I'm penciling and use a TON of white-out when I'm inking. I'd feel very sorry for the first person I tried one on. I'm sure it would be quite a mess.

APART FROM FLASH, WHAT OTHER ARTWORK DO YOU DO?

I make a living as an illustrator. My claims to fame are editorial assignments from *Rolling Stone* to *Newsweek*, advertising work from *Coke* to *McDonalds*, CD covers from *Less Than Jake* to *The Supersuckers* and now with the flash, tattooed bodies from *head* to *toe*. I also indulge myself in "fine art" and participate in as many gallery shows as time allows. The only drawback: gallery owners who prefer art that is "good" and "sells." My God, doesn't "well behaved," "nicely groomed," and "quite punctual" count for anything anymore in this crazy, topsy-turvy world?!

HOW MUCH WOULD IT COST IF SOMEONE WANTED AN ORIGINAL "M.O'C" OVER THE FIREPLACE?

I like to call my art a "great investment," or, when it gets closer to

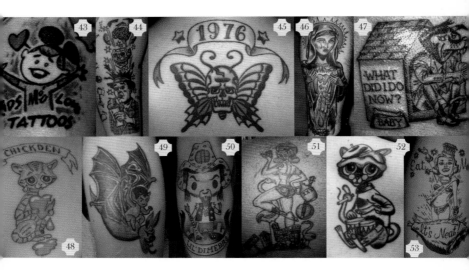

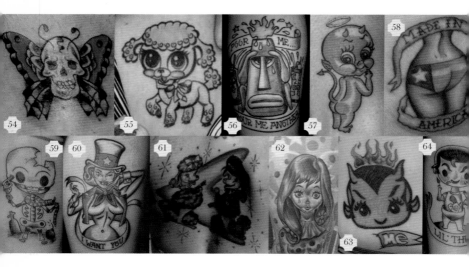

Christmas, a "great stocking stuffer." After a purchase, I call 'em "no refunds!" They range in price from, "That's way too much!" to "He must be crazy!" Right now I have the world's largest collection of Mitch O'Connell originals. I'd much rather have a larger bank account.

MUCH HAS BEEN MADE OF YOUR EXTREME GOOD LOOKS. DO YOU FIND THAT A HELP OR HINDRANCE IN YOUR CAREER?

Good question! I hope that people are able to look past my perfectly chiseled face and Herculean body to also see my great inner beauty and strength. Looks will fade over time – not in my case of course – but it's what's in your heart and soul that'll last forever. That is the real judge of one's character. In short... it's "win, win" no matter how you look at me!

DO YOU THINK YOUR KIDS WILL FOLLOW IN YOUR FOOTSTEPS?

Both of our kids love to draw. For all their lives they've seen me doodling all day long, so I'm sure it seems like a perfectly natural thing that everyone does, like having a gin 'n' tonic with breakfast.

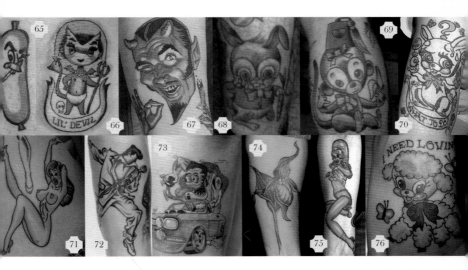

Every time my daughter Kieran completes a new drawing she asks for a piece of tape and tries to find a blank space on my studio walls to display it. Last week Leo surprised me with about six pages of tattoo flash he had come up with on his own. It was very cool to see what a 10-year-old's idea of happening flash would be (think lots of Yu Gi Oh characters). The young 'uns plan to have a Lemonade/Tattoo stand set up in front of the house this summer. Kieran will handle the refreshing thirst quenching beverages and Leo will be tattooing the Hell's Angels and sailors. For 25 cents, roll up your sleeve and he'll whip out a Sharpie®. It'll be almost as permanent as a real one!

WHO INSPIRES YOU EVERY DAY?

My family, because of their seemingly constant whining, "we want to eat," "we need shelter," or "I have to go to the hospital." Would it be too much to get a little **PEACE** and **QUIET** around here?!

CAN WE LOOK FORWARD TO MORE FLASH?

I'll keep cranking 'em out as long as folks are interested. Truthfully, I'll probably crank 'em out even if no one's interested. I always think I can do a little better.

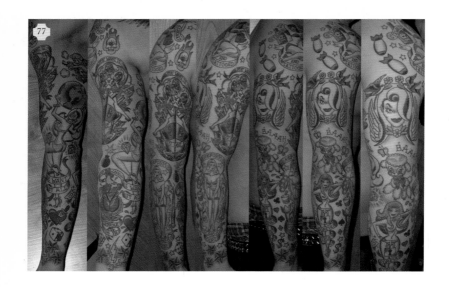

MITCH, NOT A QUESTION, BUT A COMMENT. . . I BELIEVE I
SPEAK FOR ALL OF US WHEN I SAY THAT YOU HAVE
BROUGHT JOY TO MILLIONS THOUGH YOUR GUIDANCE,
CHARITY AND ART. WE THANK YOU FOR MAKING THE
WORLD A BETTER PLACE SIMPLY BECAUSE YOU'RE HERE!

What a beautiful and appropriate way to sum up the interview! I
swore (choke) I wasn't going to cry! C'mon over here, you all! Group
hug! HEY! OUCH! Watch it with the hands. That's going to leave a
bruise!

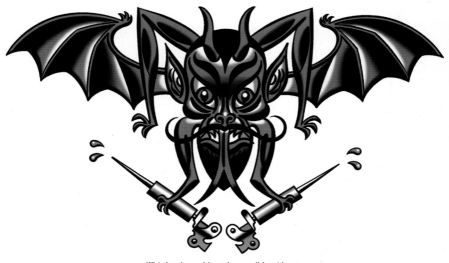

This book would not be possible without:
The old school tattooists who came up with everything.
The shops that purchased my flash.
The customers who picked my designs.
The tattooists who turned my doodles into tattoos.

Including: 1) by John Vanover of Tattoos Joe's 2) by Redbeard of Living Canvas Tattoos on Floyd Pearce 3) by John Vanover of Tattoo Joe's on Roy Lyons 4) Maya's Tattoo on Brian Wood 5) by Tim Baxley of Southside Tattoos 6) by John Vanover of Tattoo Joe's 7) ? 8) by Russ Abbott of Psycho Tattoo on Nathan Martin 9) by Retro Dave of Retro Tattoo's on CrAzY Best 10) by Barry Sturges on Angela Ferretti 11) by Dave Waugh of Jinx Proof on Sarah Miller 12 by Billie Brown of Pain and Wonder Tattoo on Sonja Quiles 13) by Philly John 14) by Abraham of Timbomb Tattoo on Jenny Cooke 15) by Alex Higgins of the Tattoo Factory 16) by Frank Wilson on Emilie Jackson 17) by Turk of Guru Tattoo 18) by Reverend Mike of 1st Amendment Tattoo on Sarah Sandford 19) by Johannes Willms of Jojos Tattoos 20) by Matt Sawdon of Tattoo Evolution on Cheryl "Sassypants" Morris 21) by John Vanover of Tattoo Joe's 22) by Brandon Notch of Sacred Saint Tattoo on Noelle Michon 23) on Rosie Pop 24) by Aubrey Whitaker of New U Tattoo on Wendy Broderick 25) by Micheline Love on Micheline Love 26) by Matt Lampi of Get to the Point 27) by John Vanover of Tattoo Joe's 28) by Miss Nikki of Rockets 29) on Ash of Retro Rebels 30) by Ash of Retro Rebels on Louise Coutts 31) by Anastasis of Cosmo Tattoos on Debbie Sheringham 32) by Johanna of Bluebird Tattoo on Lollo 33) by Carson of Scotty's on Jeff Martin 34) by Errol of Inkstitution Tattoo on Anneke Knip 35) ? 36) by John Vanover of Tattoo Joe's on Roy Lyons 37) ? 38) by Adam Lauricella of Graceland Tattoo 39) by Alex Higgins of the Tattoo Factory 40) by Adam Lauricella of Graceland Tattoo 41) by Mick Nickels 42) by Andrea Daniel of Body Language Tattoos on Cathy 43) by Phil Colvin of Liberty Tattoo on Tim Baxley 44) on Steve Legend 45) by Smilin' Dave of Federal Hill Tattoo on Sarah O'Donnell 46) by Wes Diffie of Aganist the Grain Tattoo 47) by Bubba Baker of Tattoo This! 48) by Barry Sturges on Angela Ferretti 49) by John Vanover of Tattoo Joe's on Matt Morgan 50) by Byron Weeks of Earth's Edge Tattoo 51) by Bubba Baker of Tattoo This! 52) by Evette Wright 53) by Ray Bigness of Halo2 on Gia Terpstra 54) by Dominic Piccirillo of A Second Skin Tattoo 55) by Evette Wright 56) by Keith Elliott of Thrill Vulture Tattoo Studio 57) by Jim Class of White Tiger Tattoo 58) by Stelios of Eternal Tattoos 59) Dominic Piccirillo of A Second Skin Tattoo 60) by Mel-Mel 61) by Dave Sanchez of All Hallows Ink on Renee Hall 62) by Jeremy Riley of Art Godoy's Funhouse 63) by Barry Sturges on Angela Ferretti 64) by Dominic Piccirillo of A Second Skin Tattoo 65) by Charlie Forbes of TrustFaith Tattoo 66) by Jesse Lewis of Dream Illustration on Kay Davis 67) by Bee Bayoan on Matt Payne 68) by Tomi Kuusisto of Unholy Living Dead on Janne Lepisto 69) by Tomi Kuusisto of Unholy Living Dead on Janne Lepisto 70) on Danny Hardacre 71) by Vinnie of Atlantic Citys Hot Rod Tattoo on Dan Rossano 72) of Tattoo Eus 73) on Ivan Radojcic by Darryn of Dermagraphic Tattoo Studio 74) by Hannah Aitchison of Deluxe Tattoo on Russell Zanca 75) by Frank of Get Lucky Tattoos on Jens Rank 76) by John Vanover of Tattoo Joe's on Kelly Cline 77) by Russ Abbott of Psycho Tattoo on Nathan Martin

15

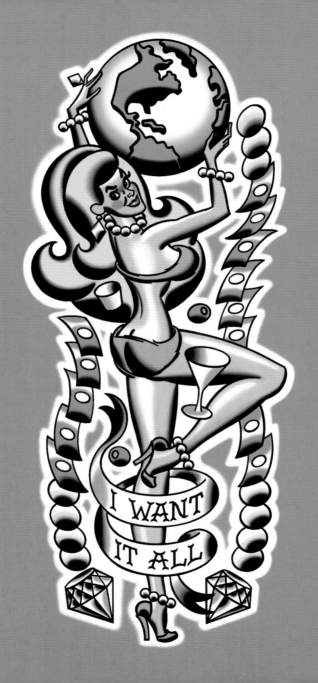

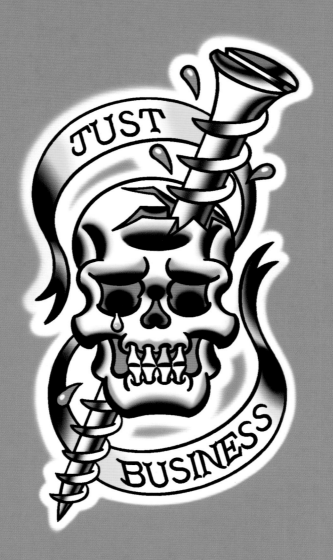

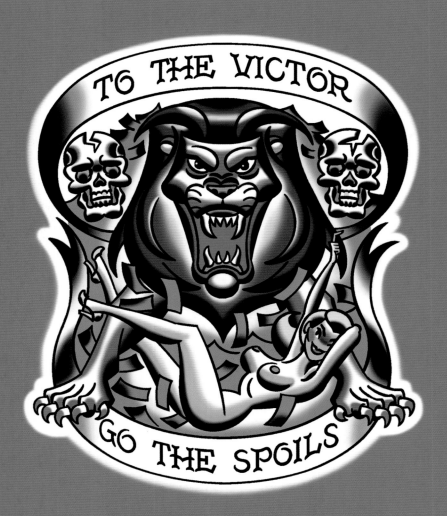

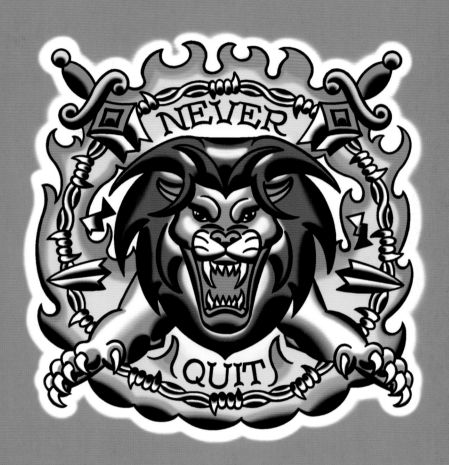

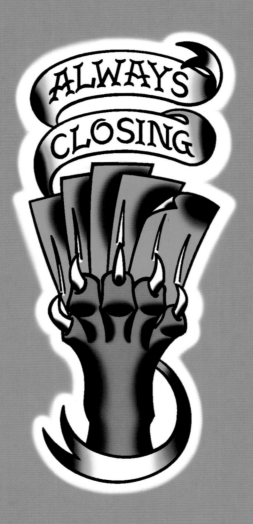

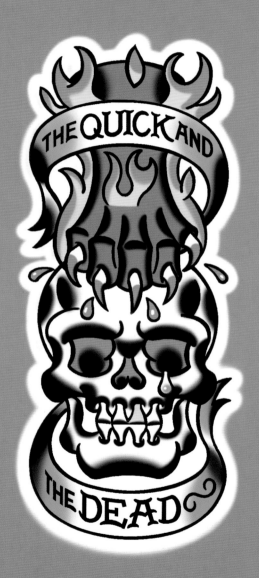

THE QUICK AND

THE DEAD

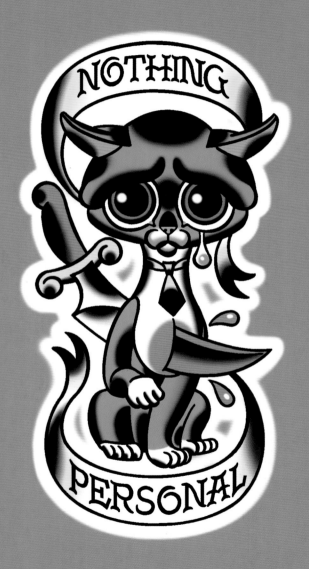

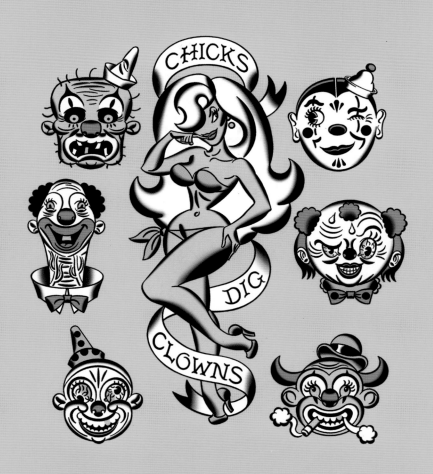

CHICKS DIG CLOWNS

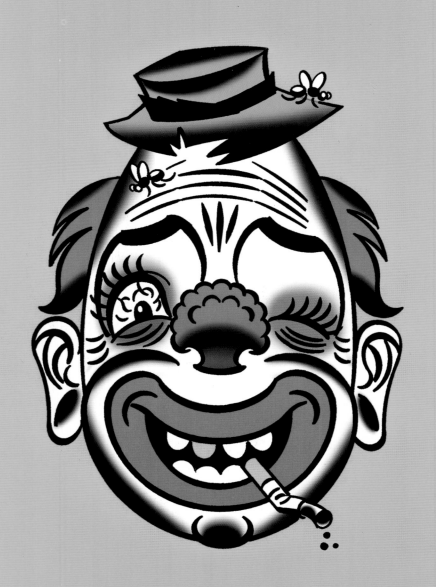

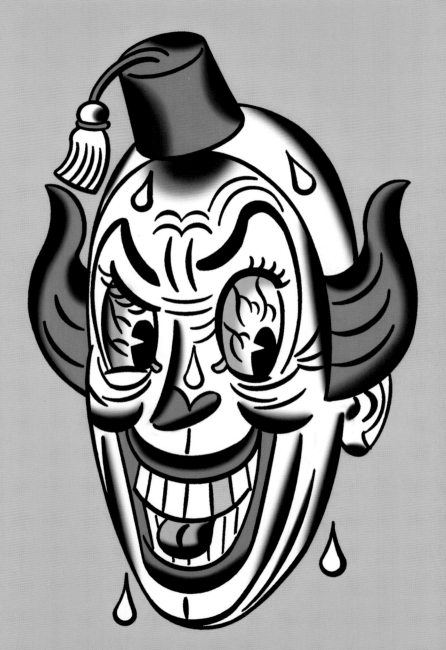

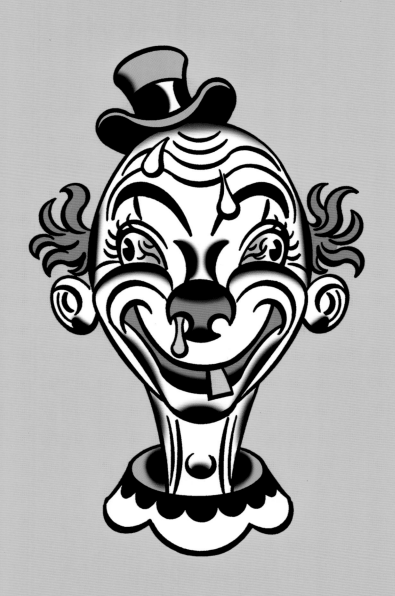

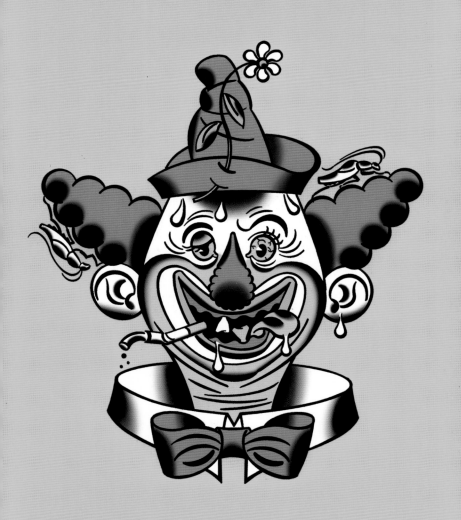

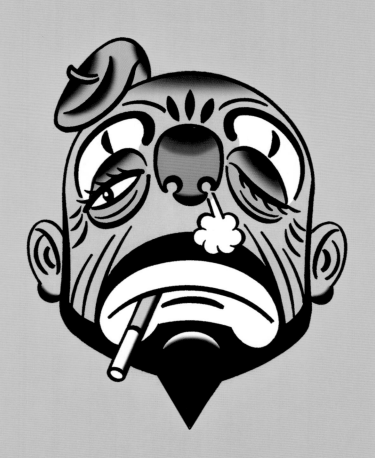

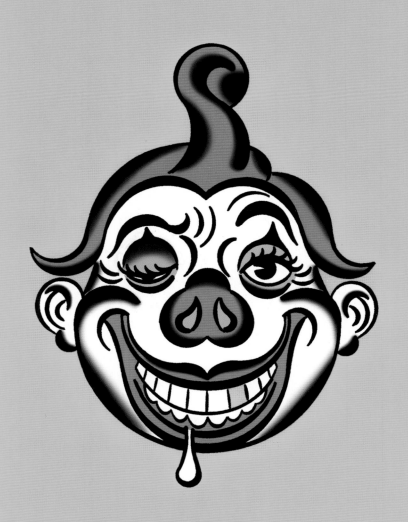

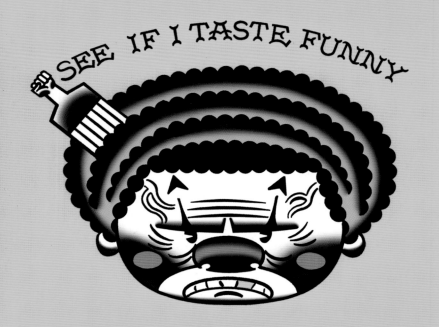

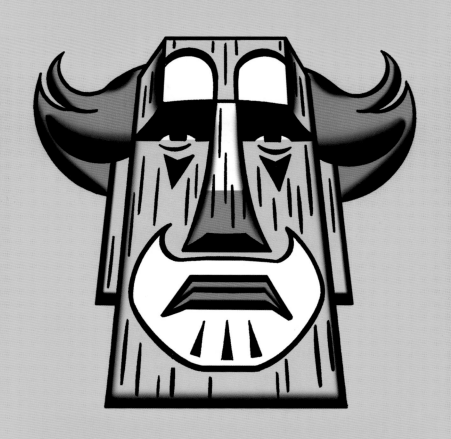

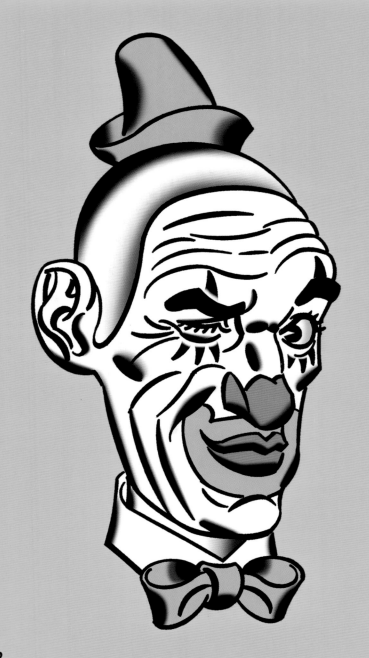

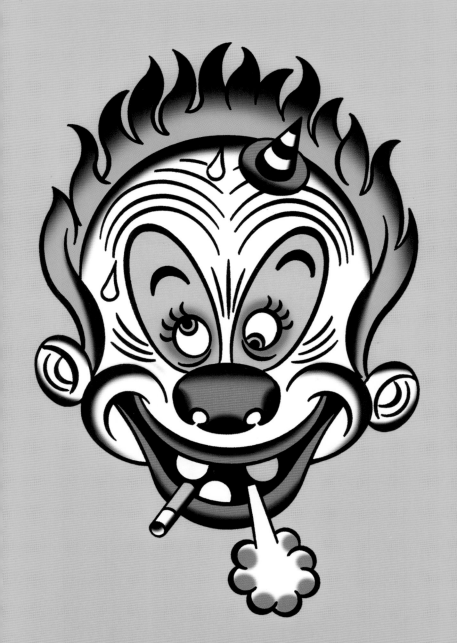

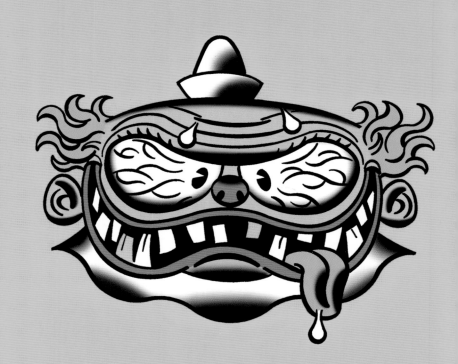

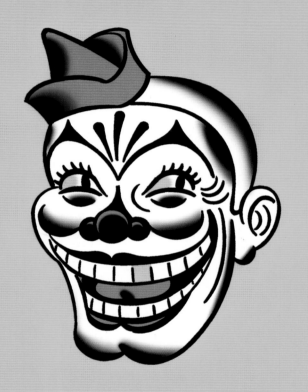

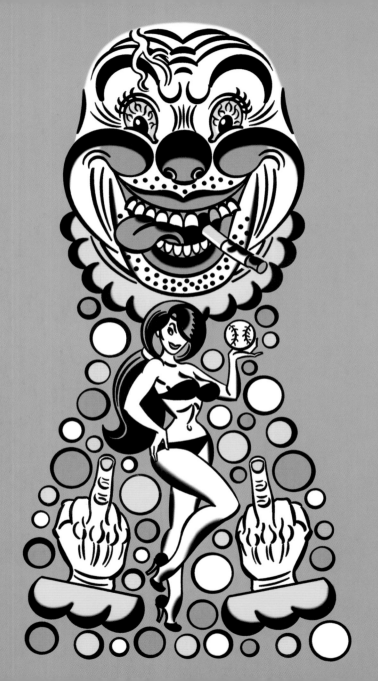

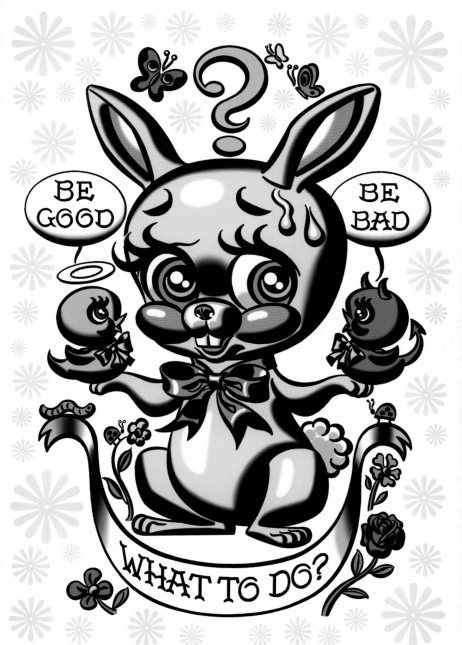

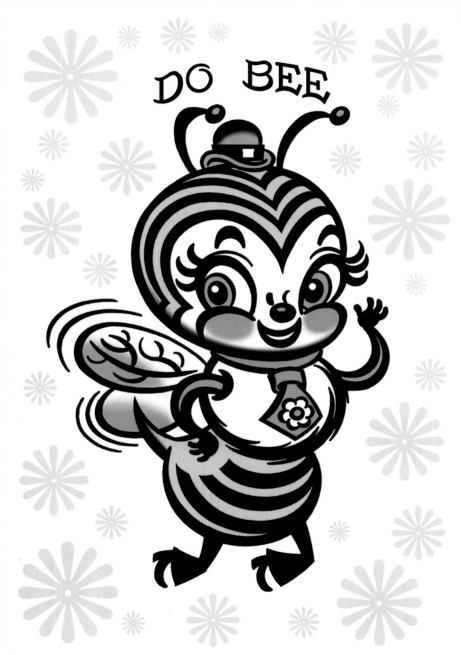

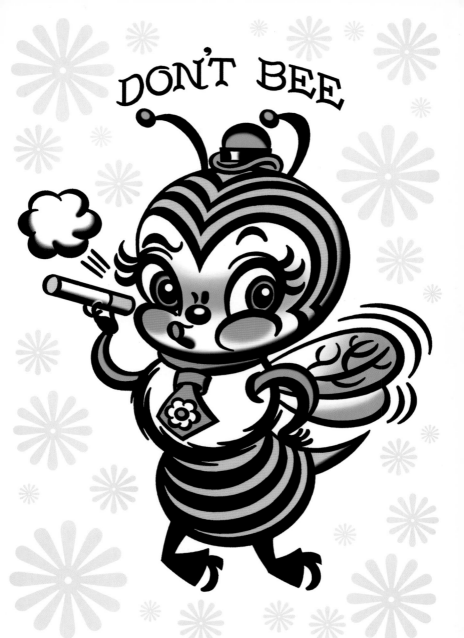

DON'T BEE

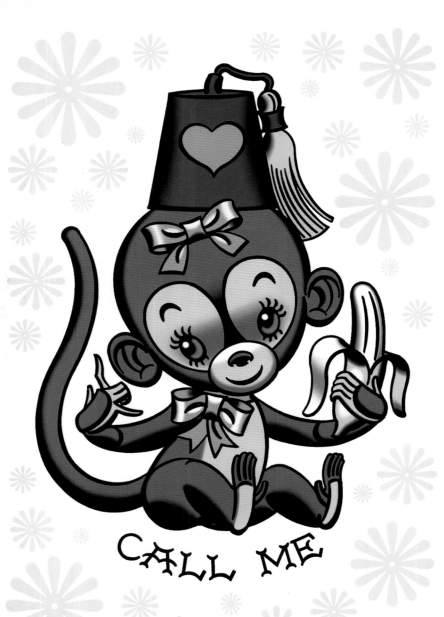

CALL ME

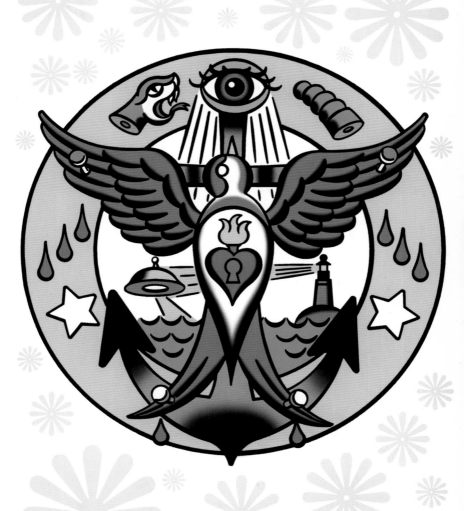

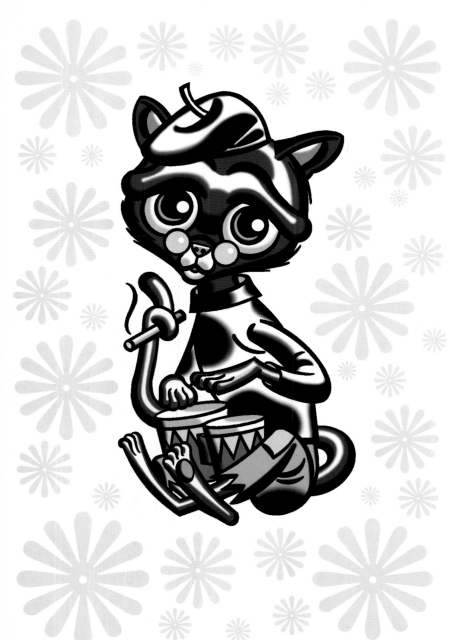

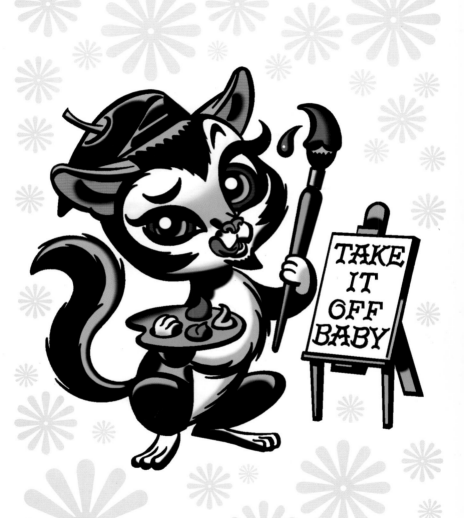

43

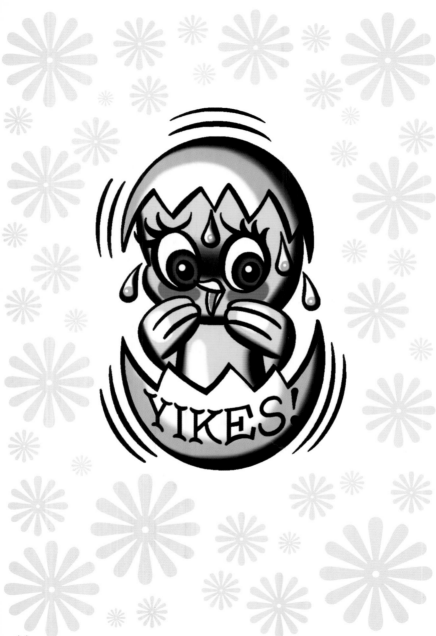

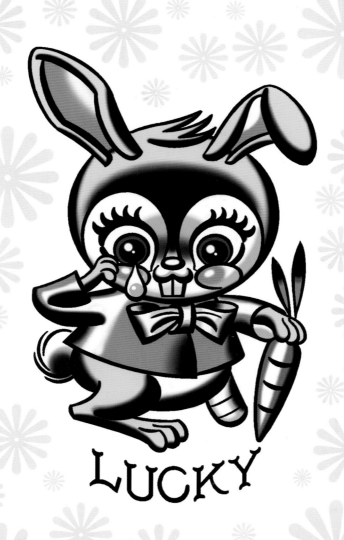

LUCKY

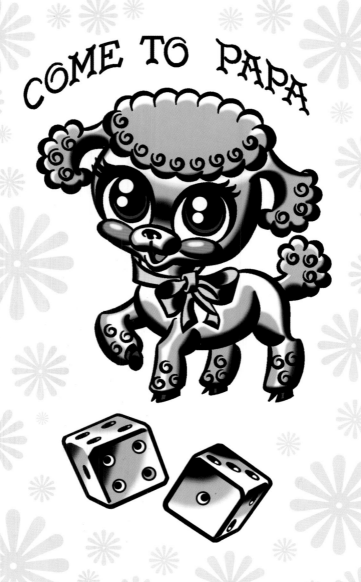

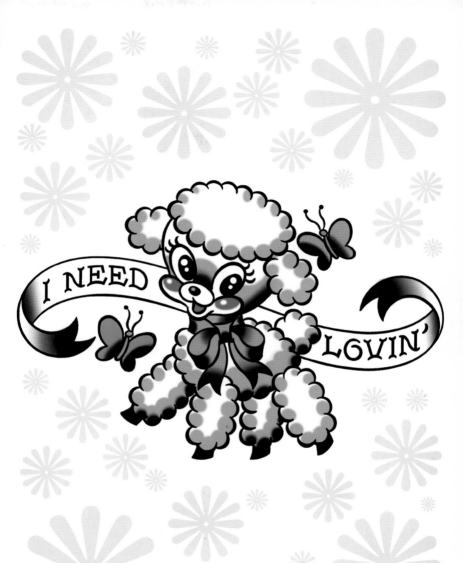

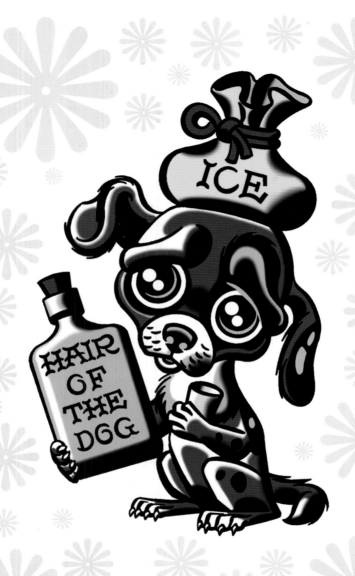

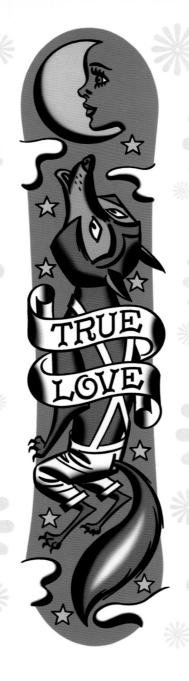

49

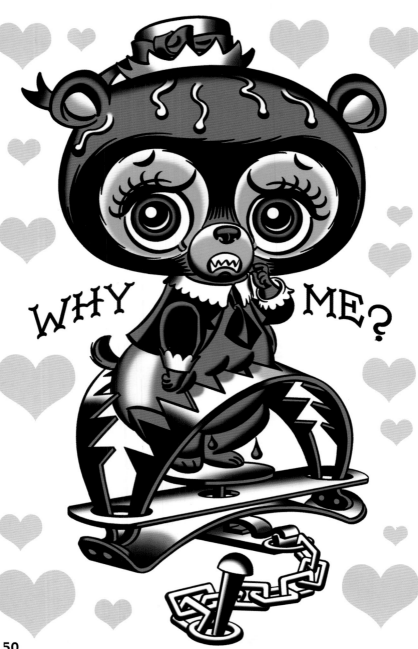

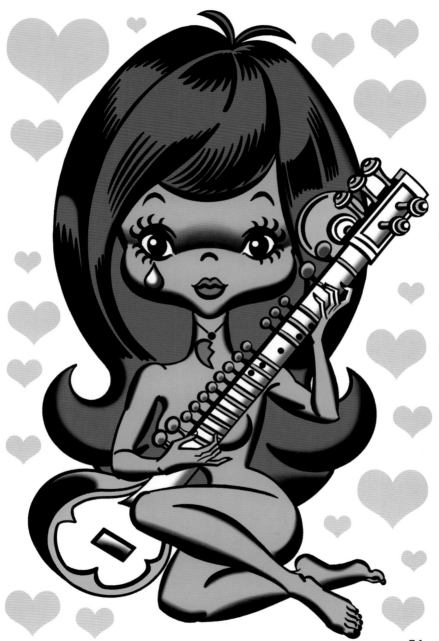

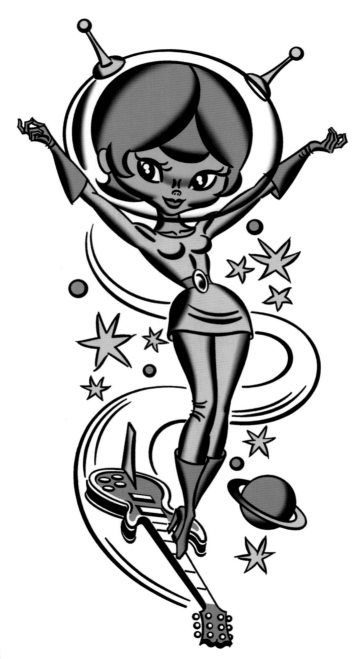

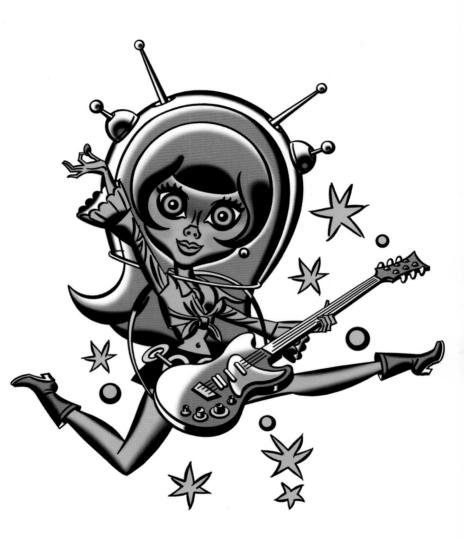

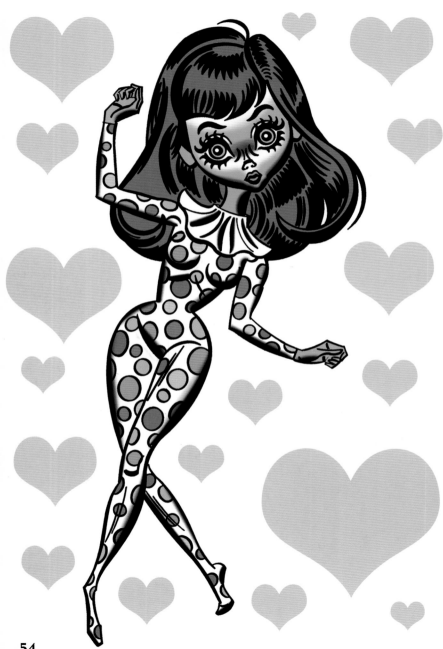

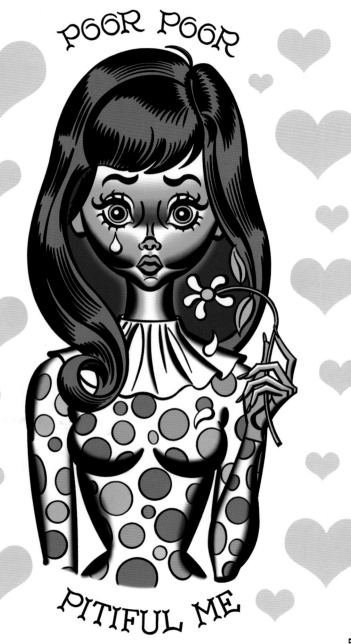

POOR POOR

PITIFUL ME

55

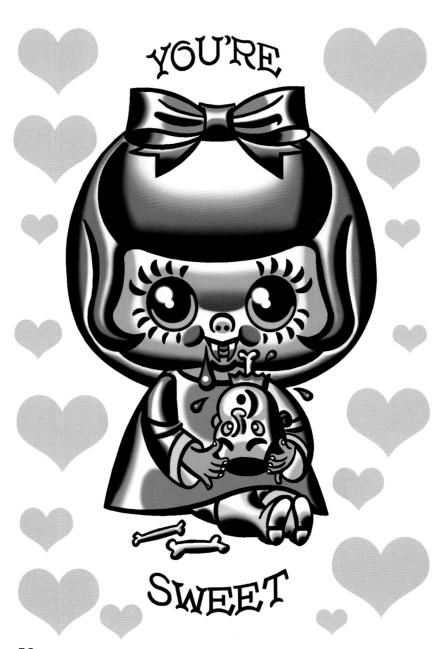

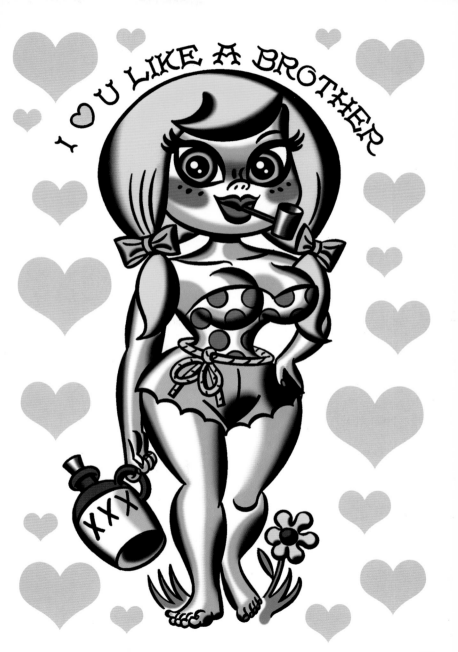

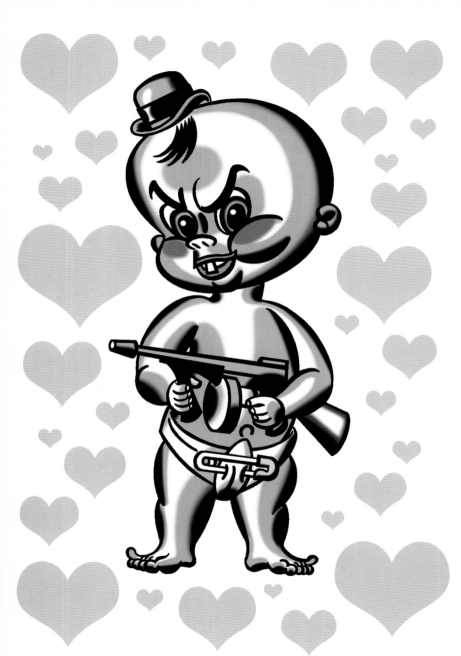

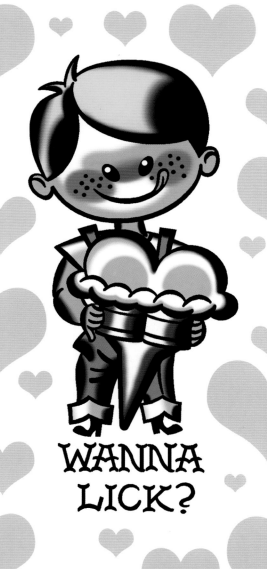

WANNA LICK?

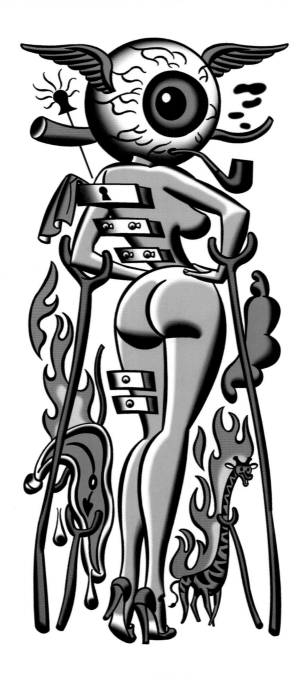

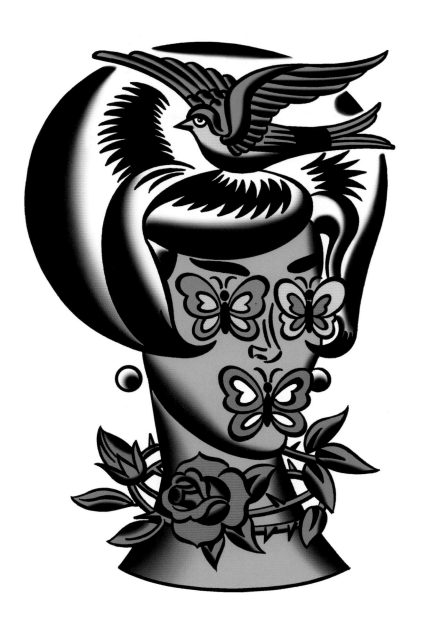

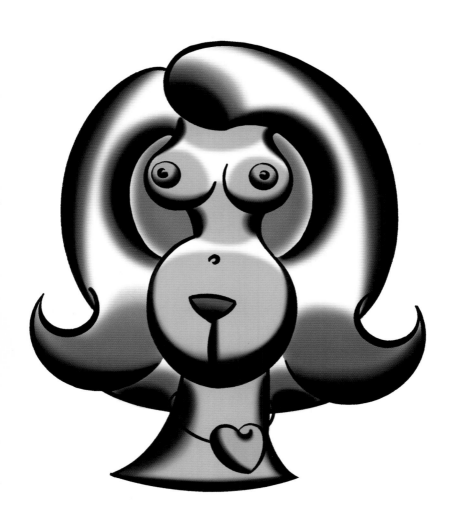

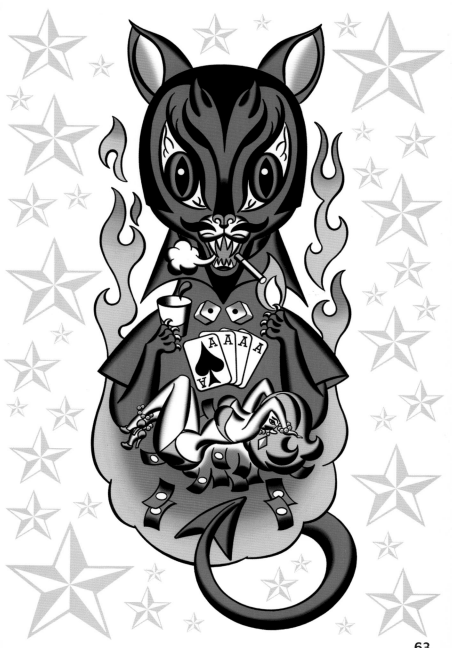

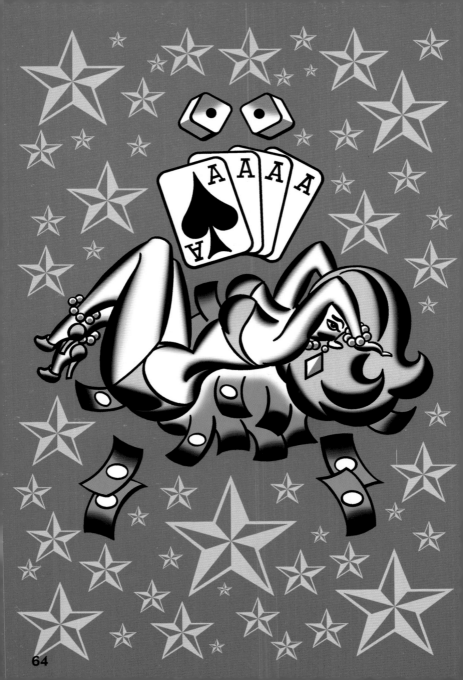

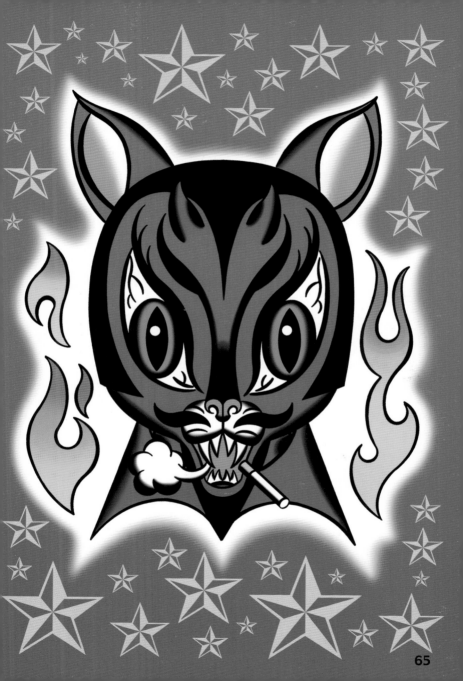

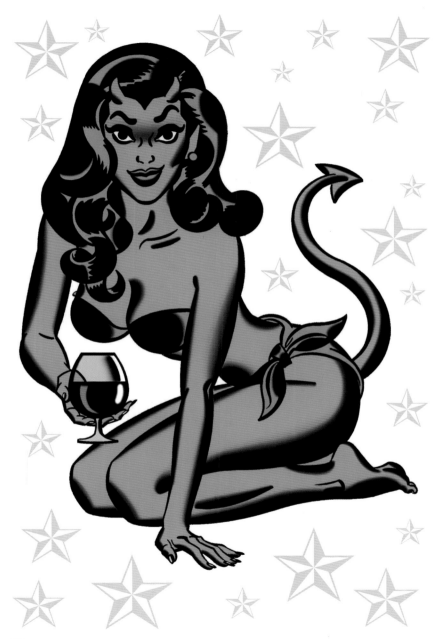

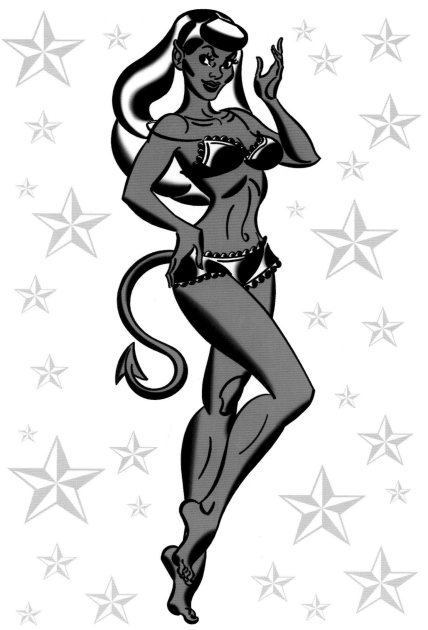

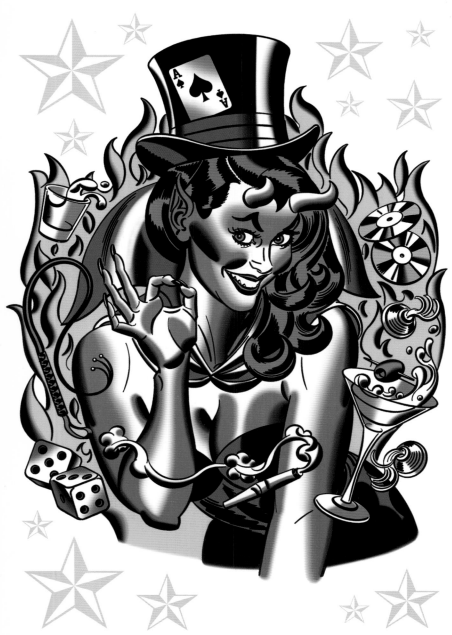

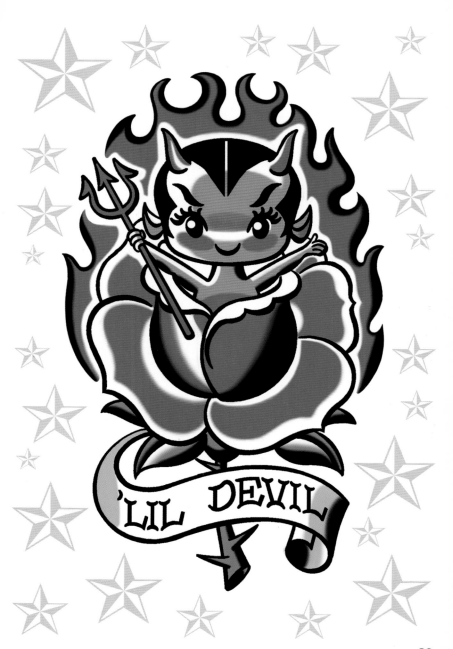

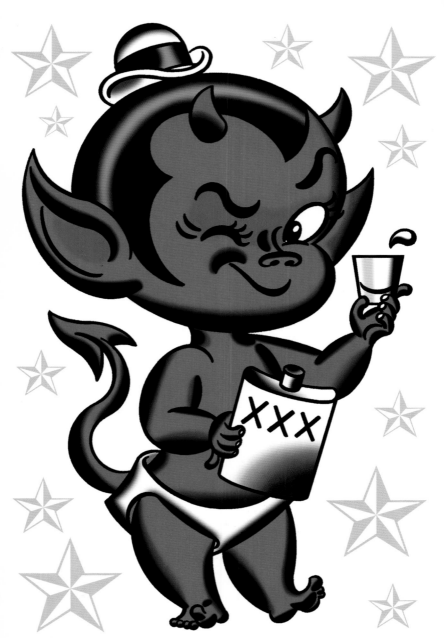

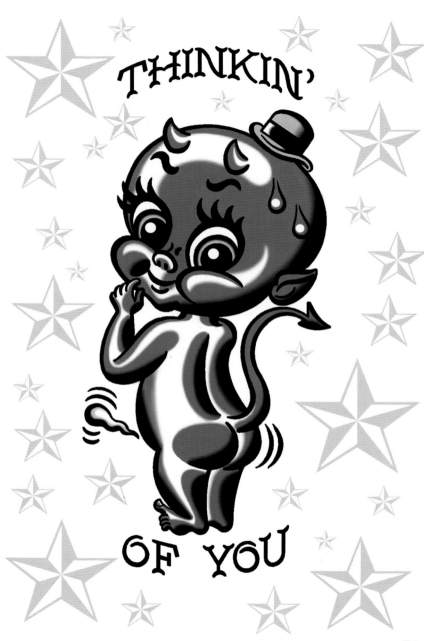

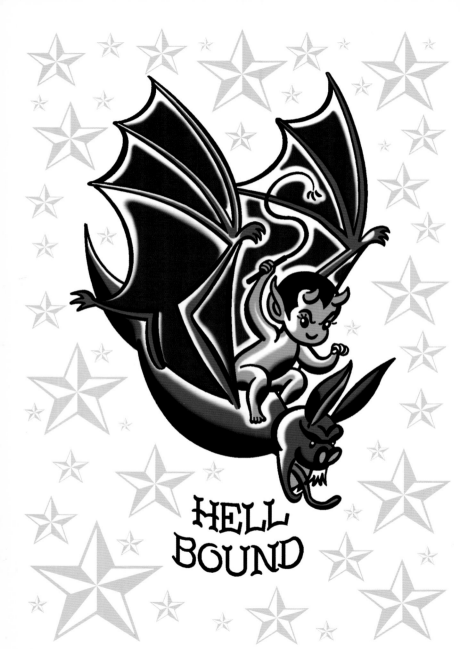

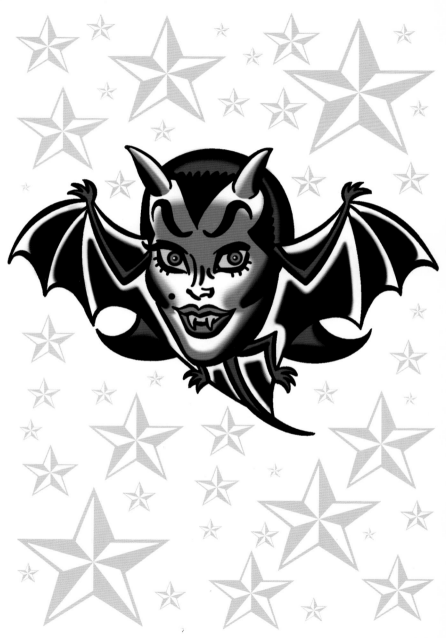

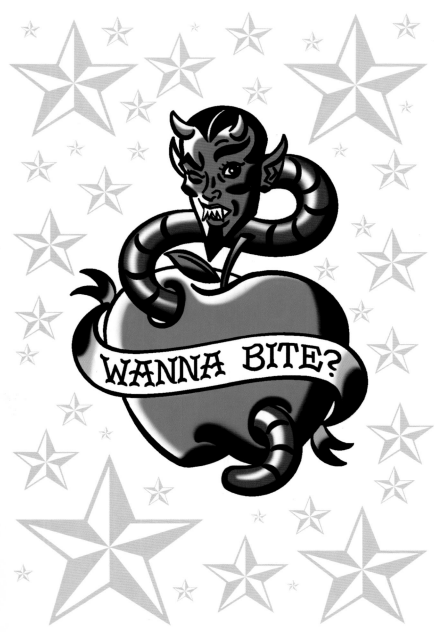

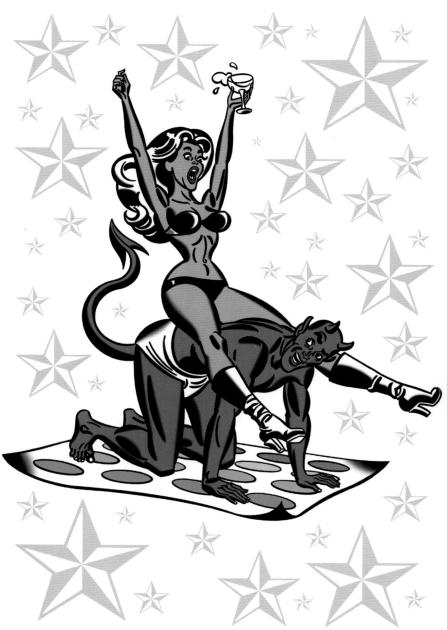

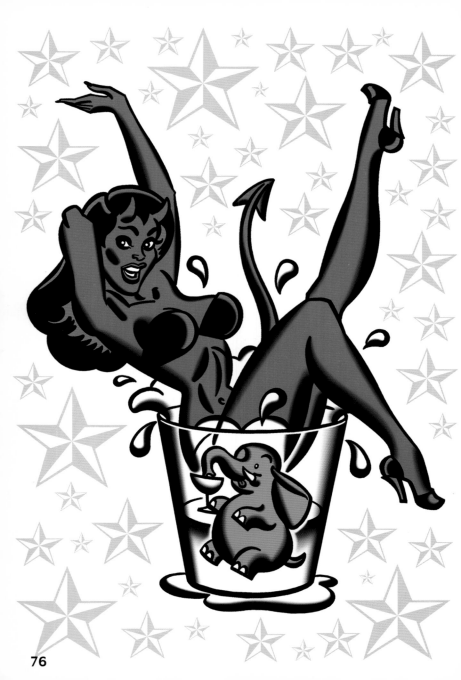

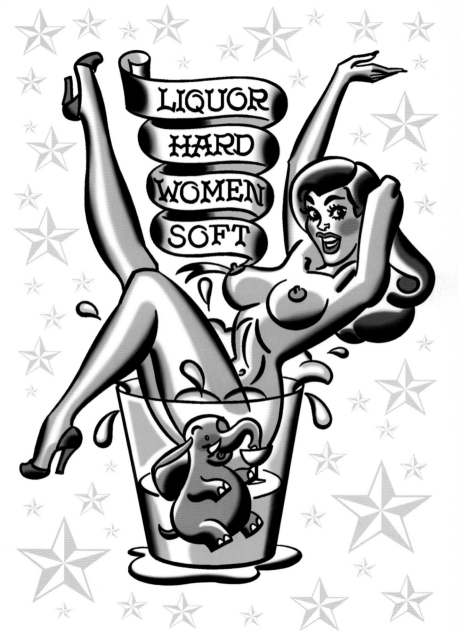

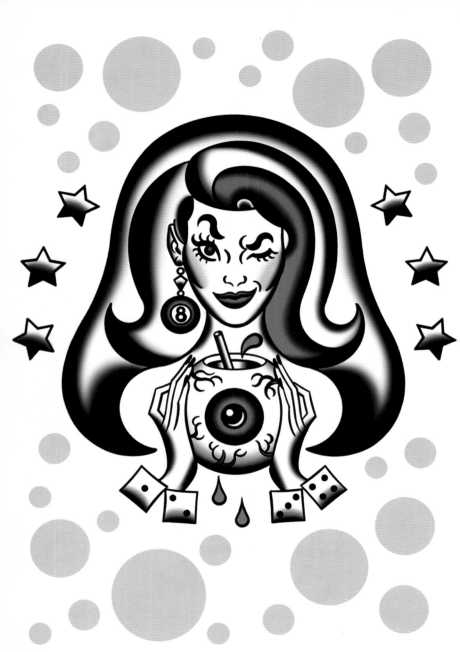

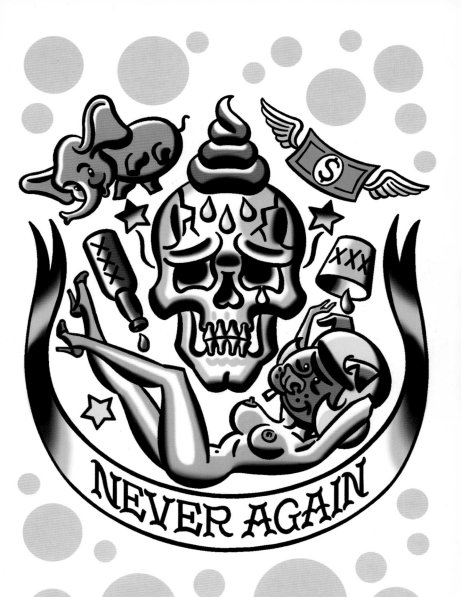

NEVER AGAIN

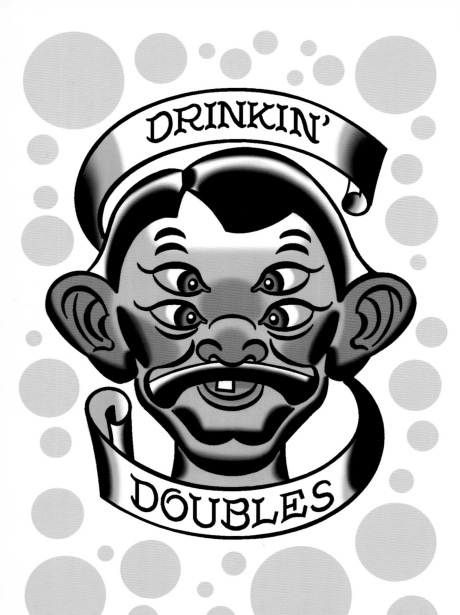

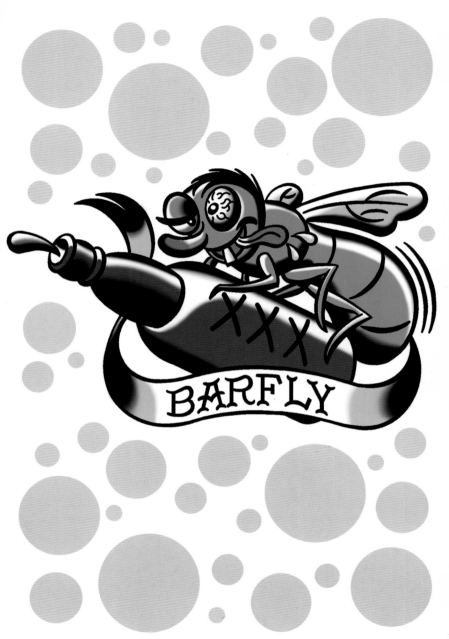

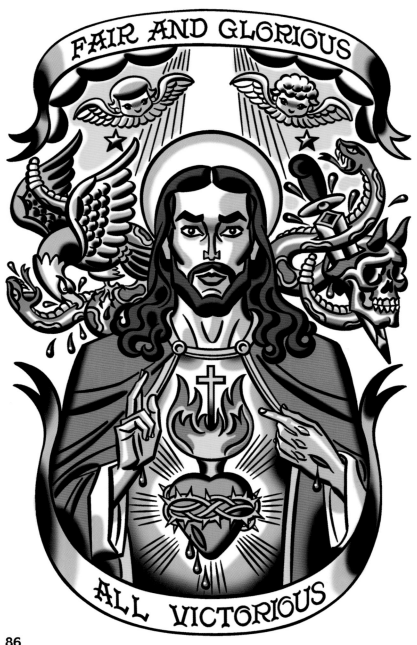

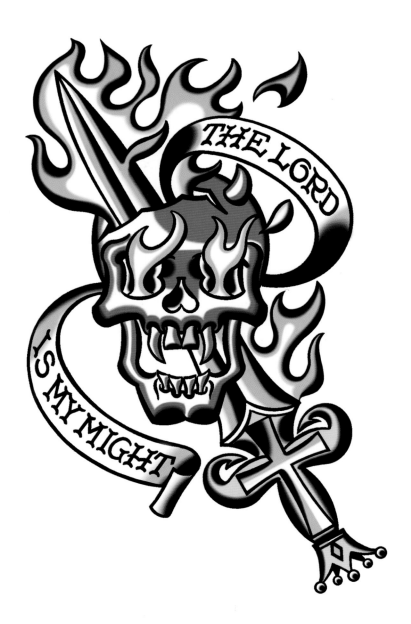

THE LORD

IS MY MIGHT

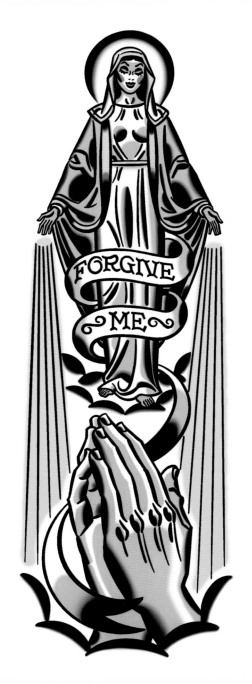

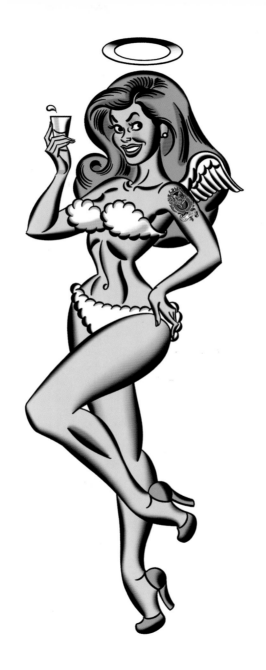

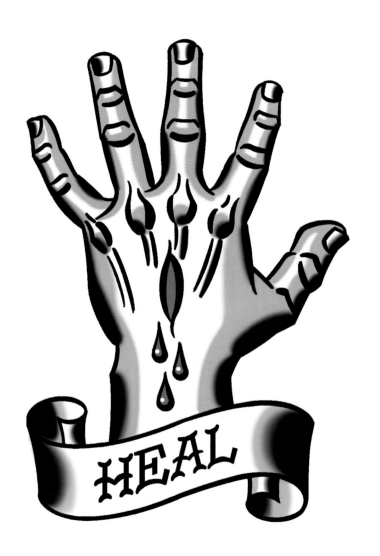

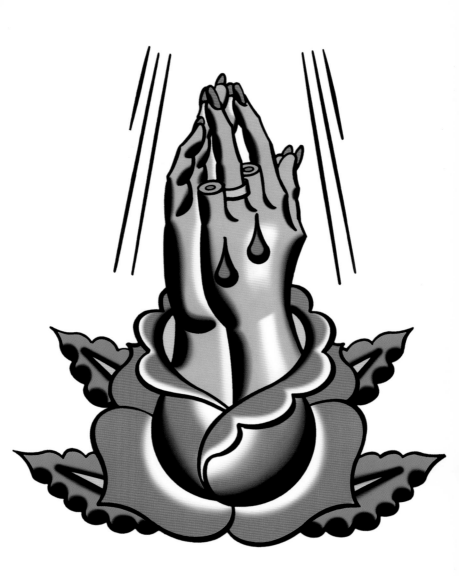

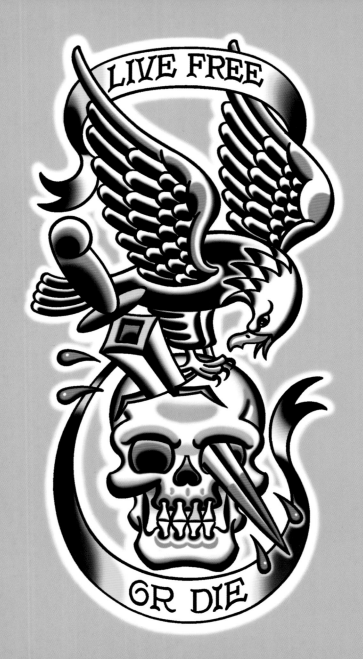

LIVE FREE

OR DIE

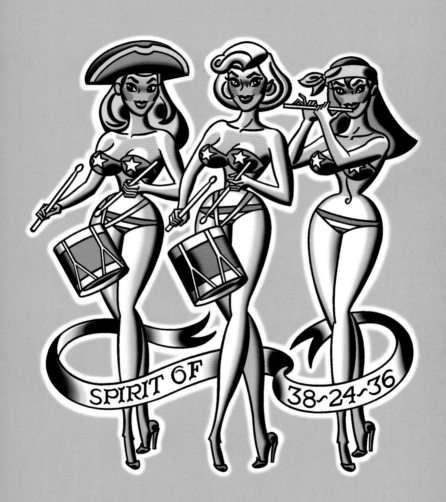

SPIRIT OF 38~24~36

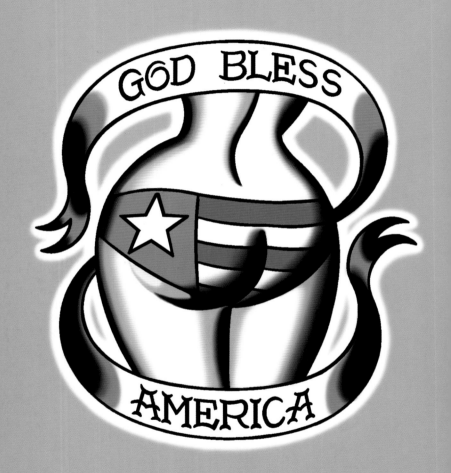

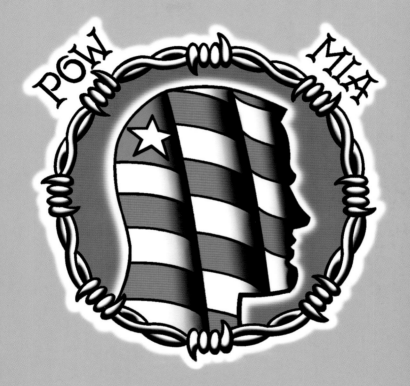

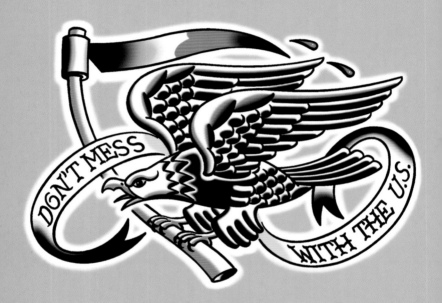

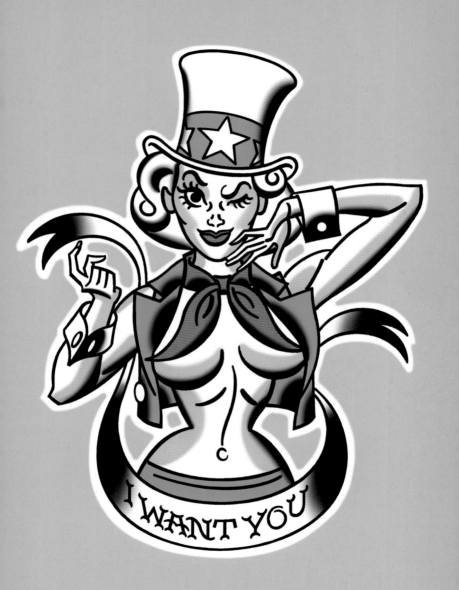

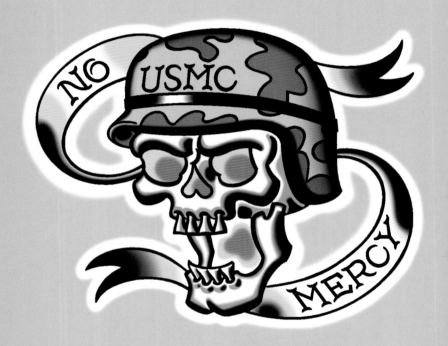

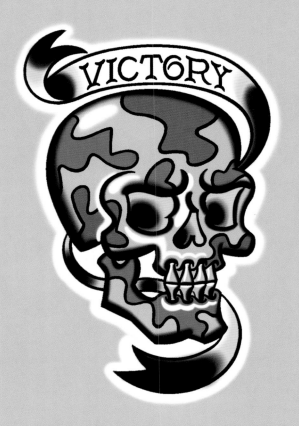

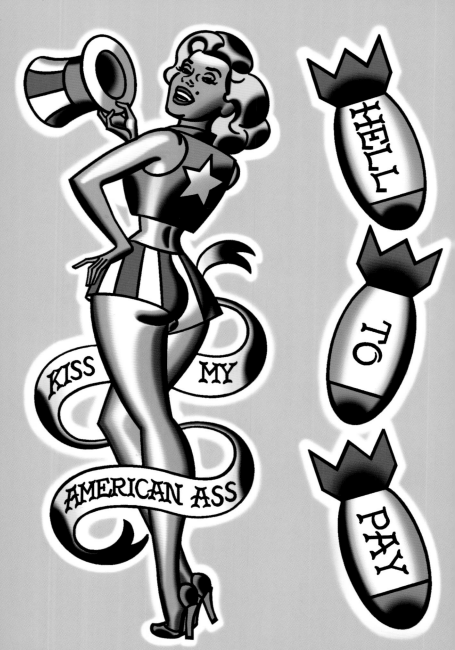

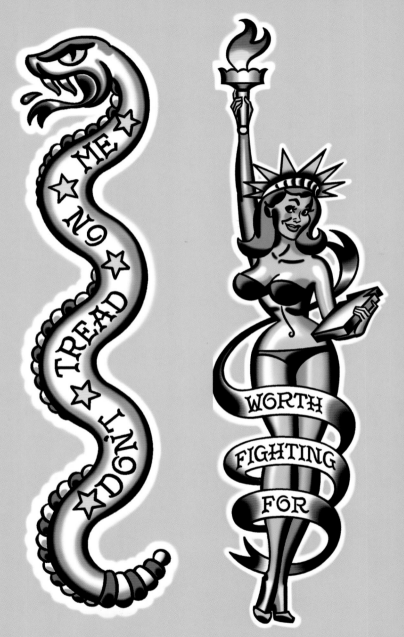

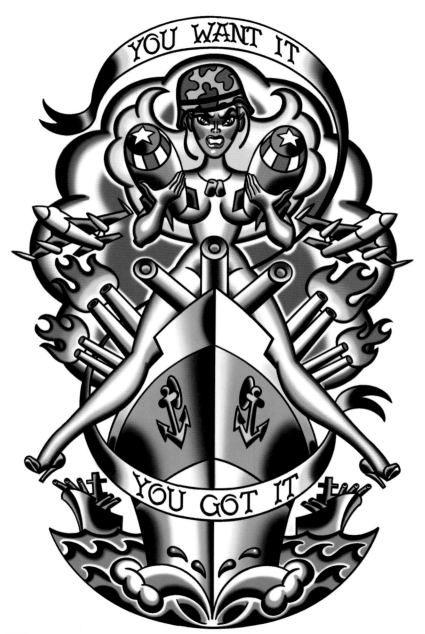

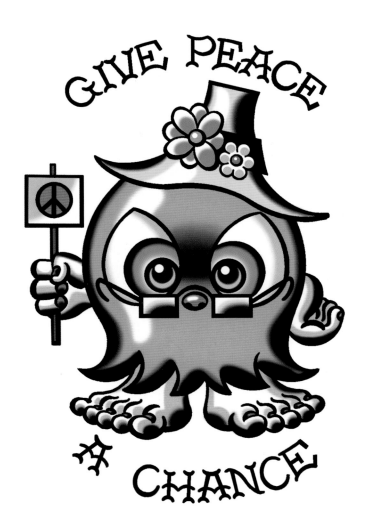

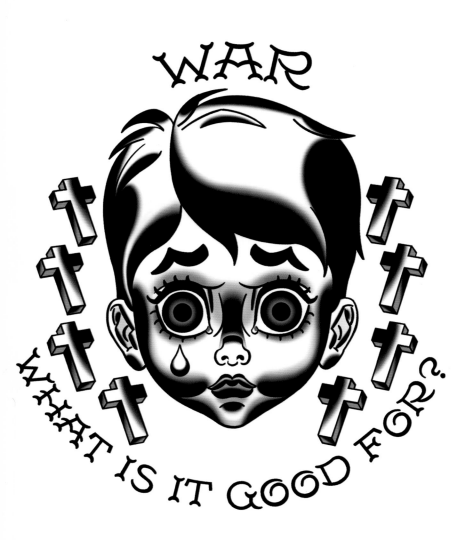

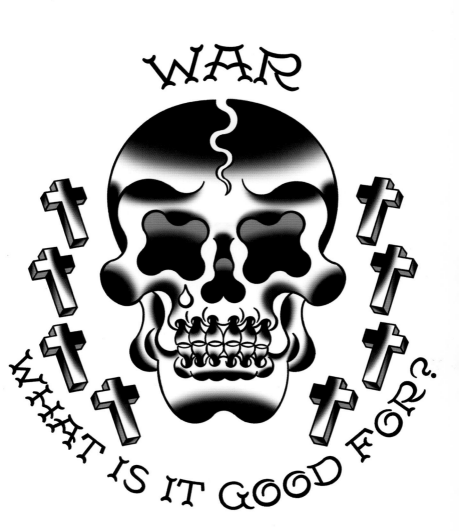

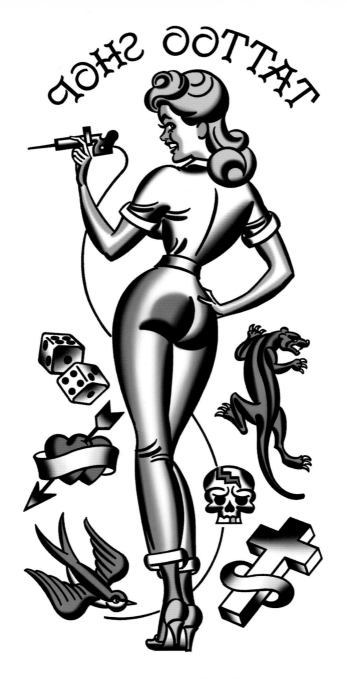

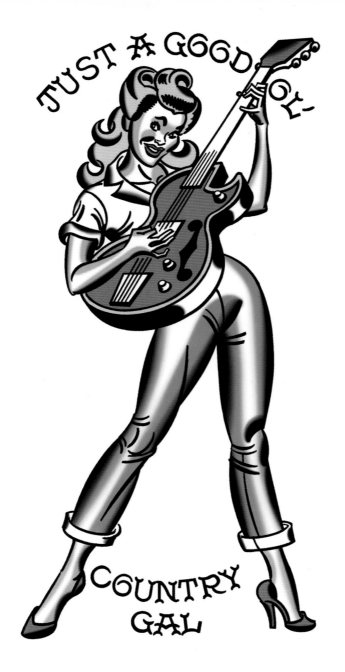

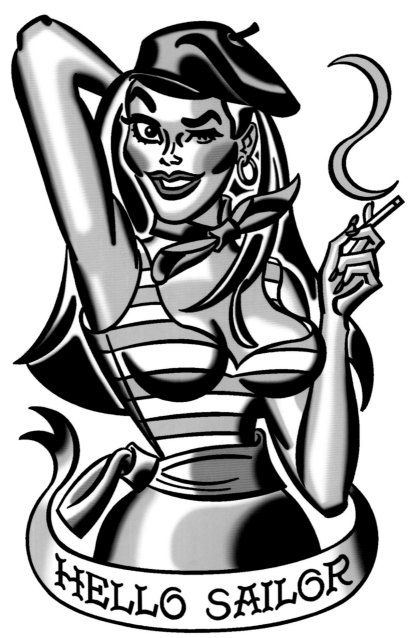

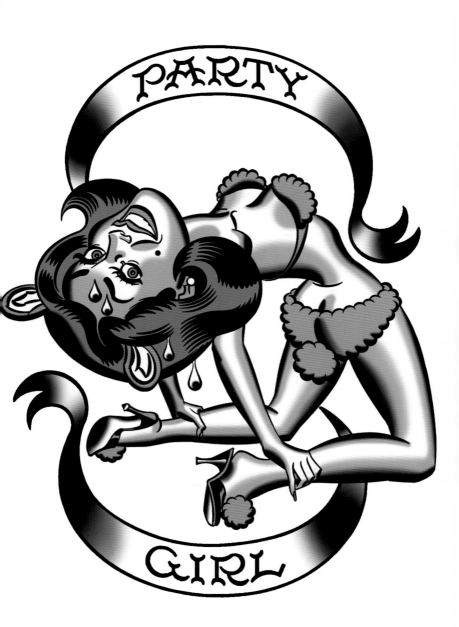

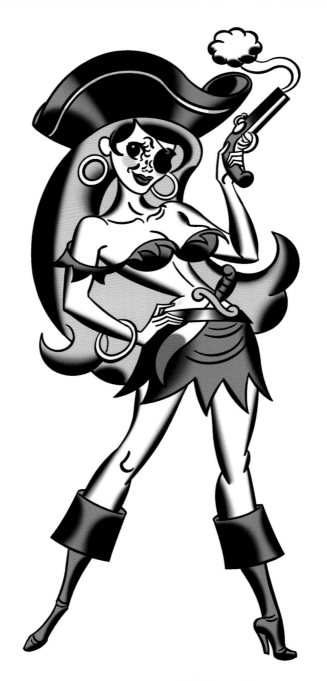

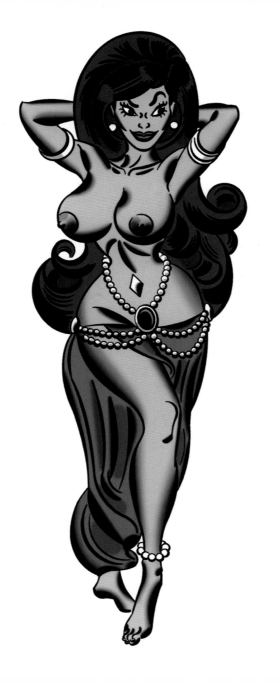

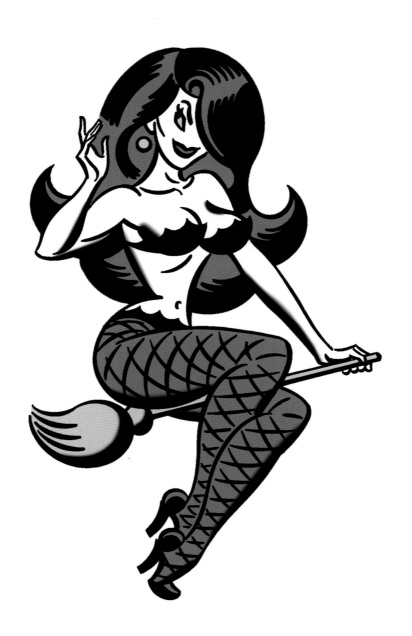

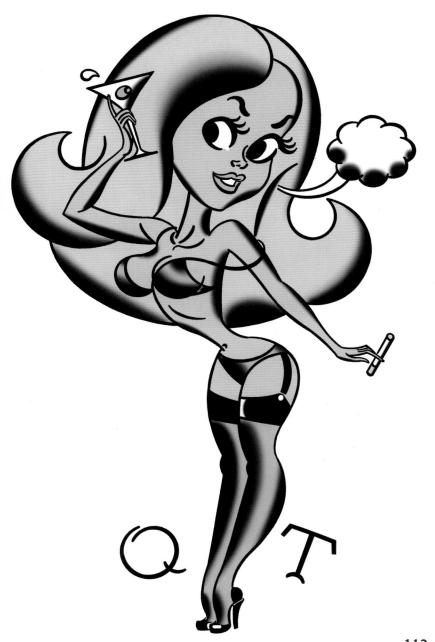

QT

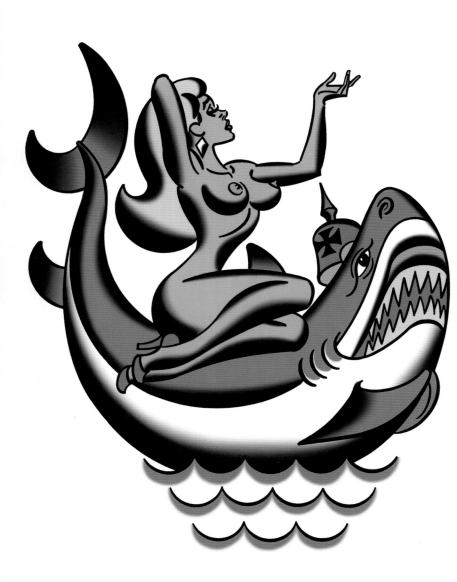

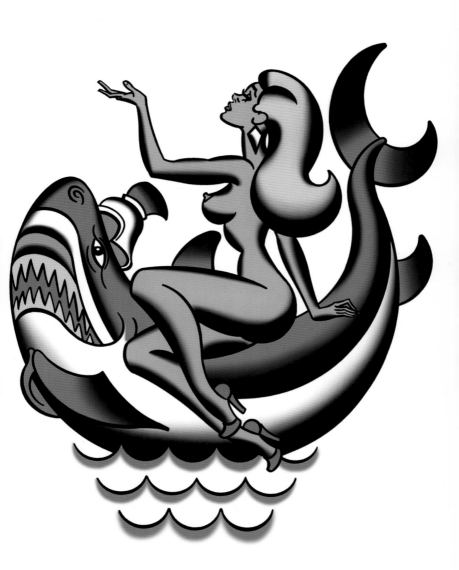

115

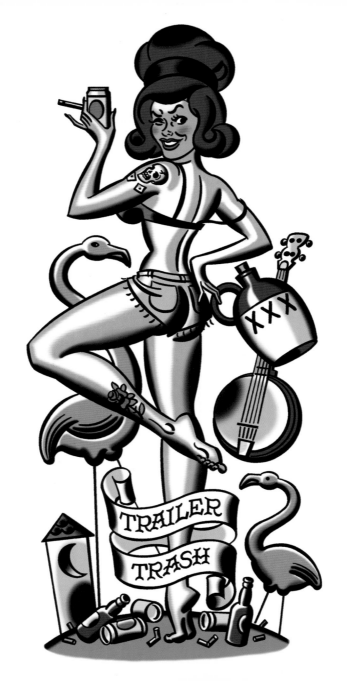

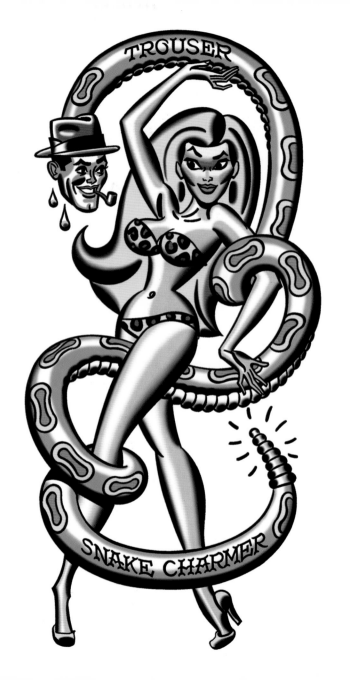

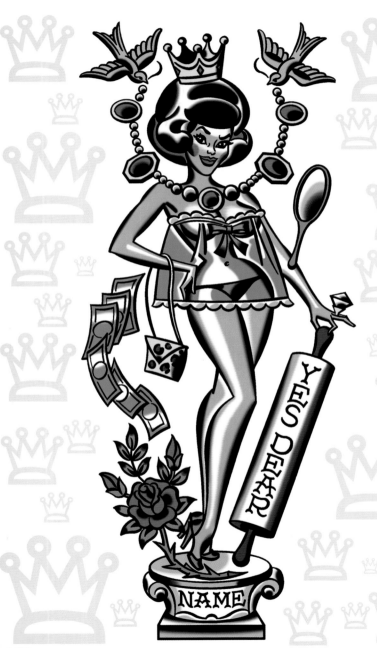

YES DEAR

NAME

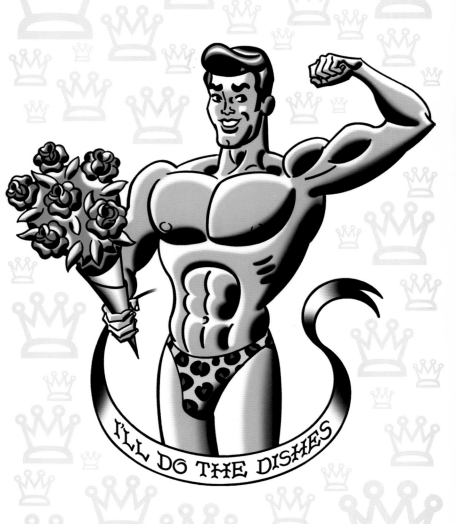

I'LL DO THE DISHES

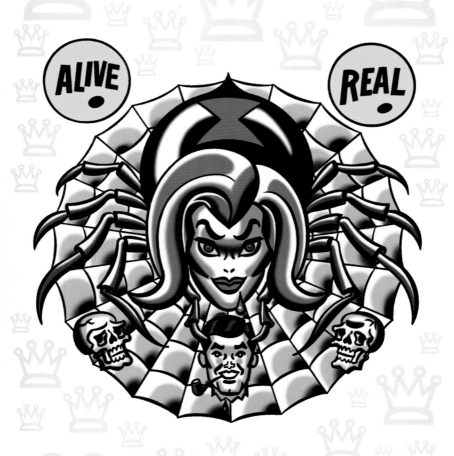

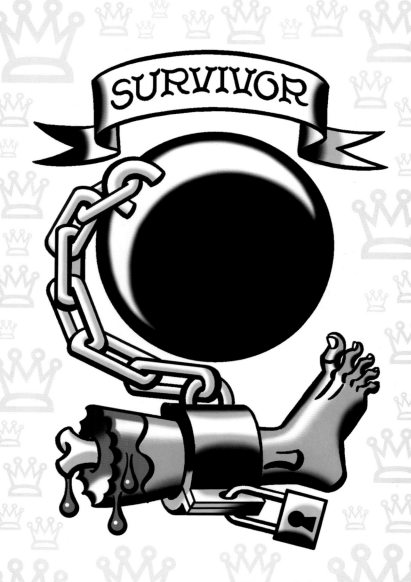

121

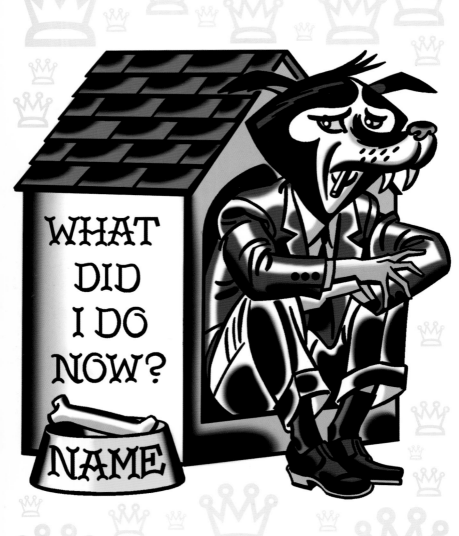

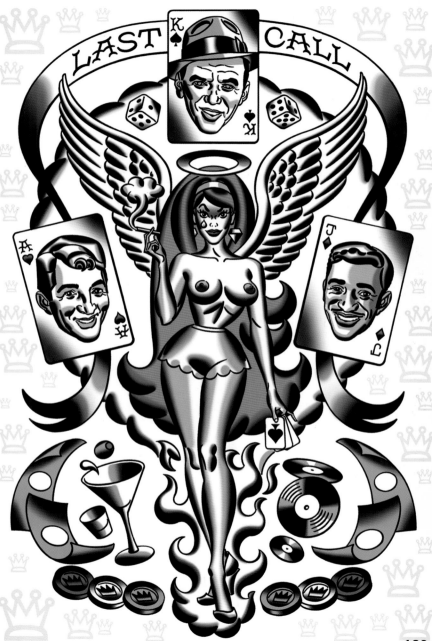

123

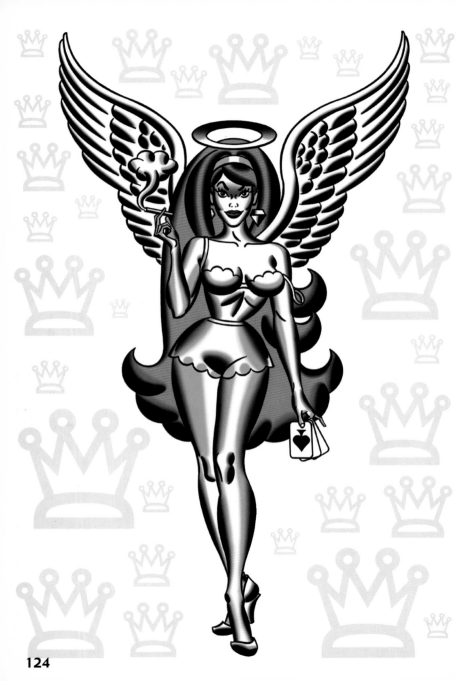

124

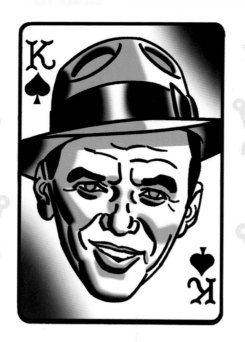

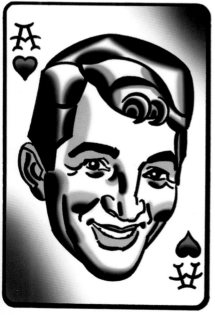

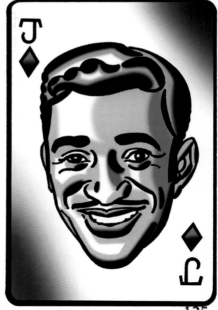

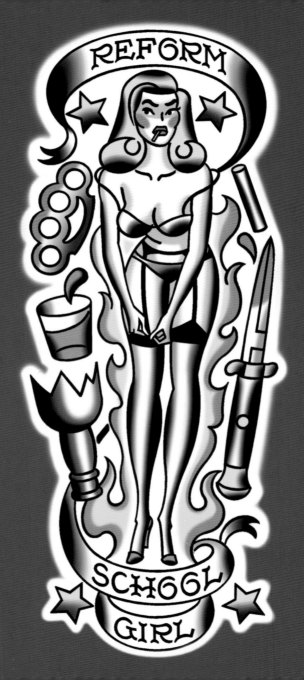

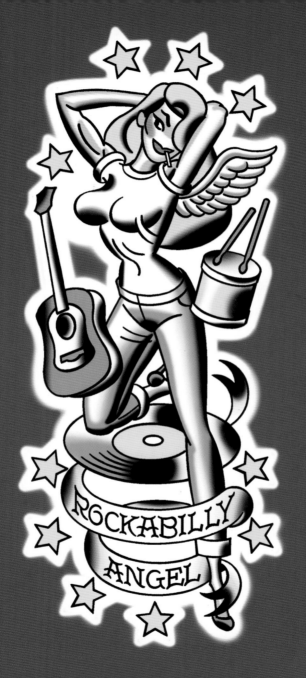

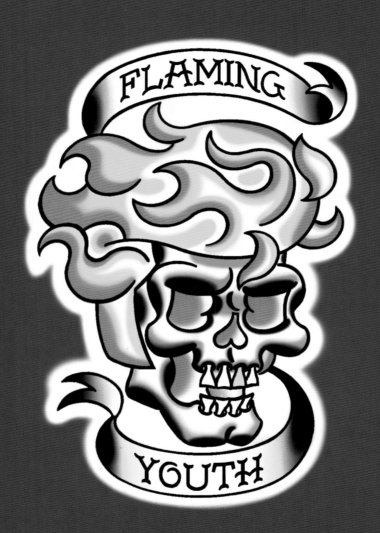

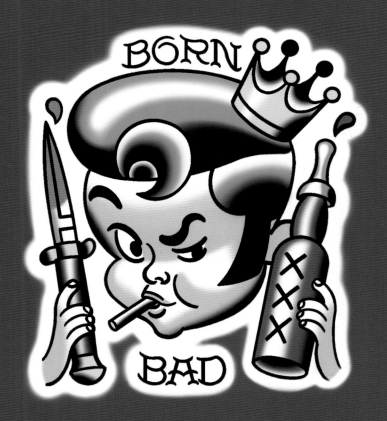

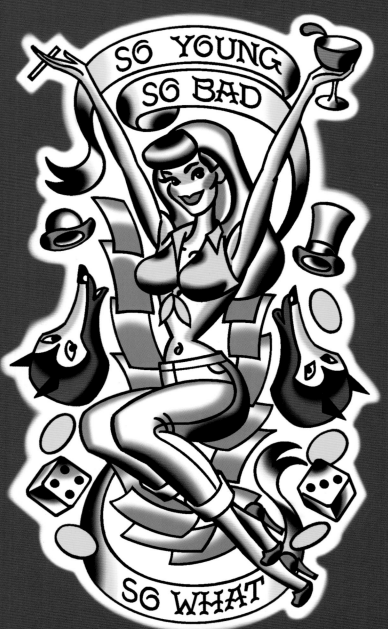

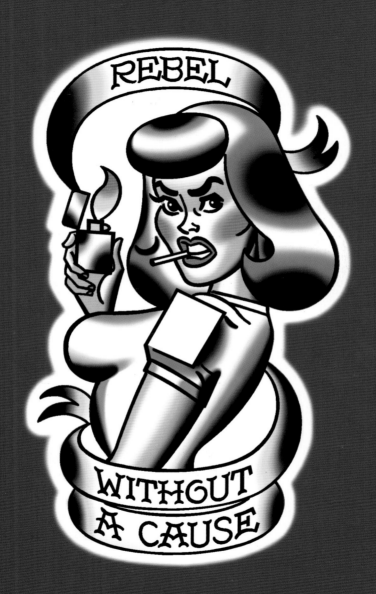

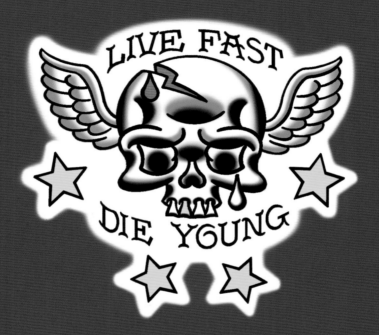

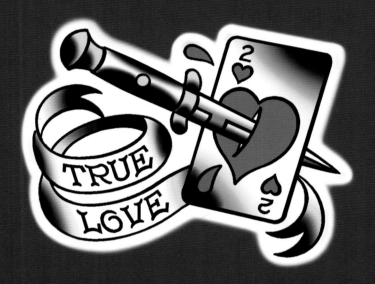

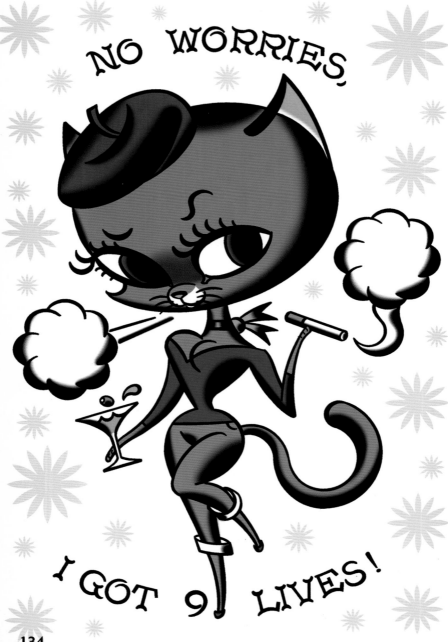

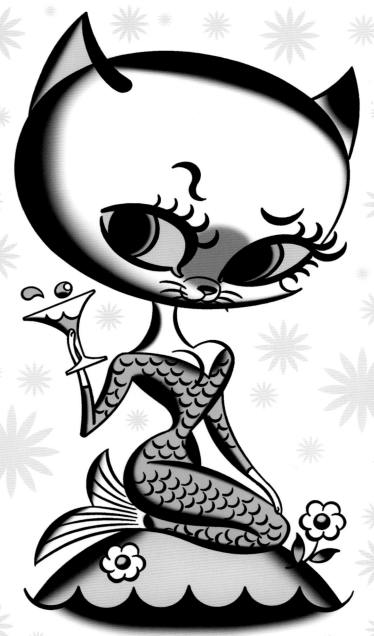

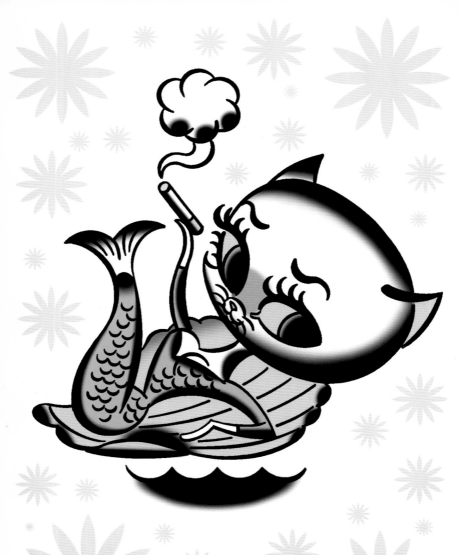

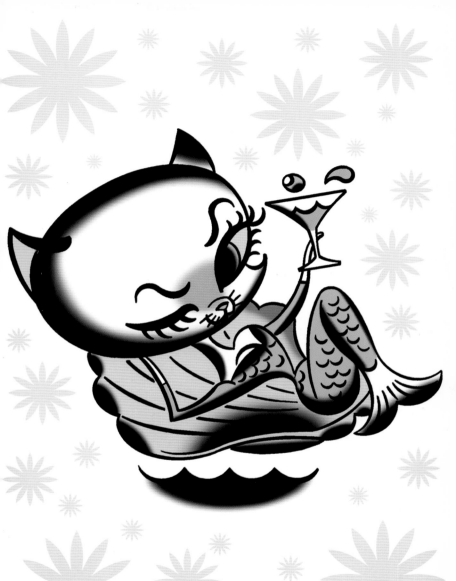

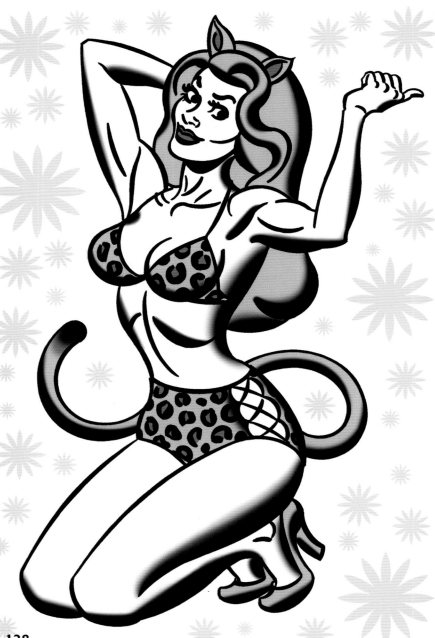

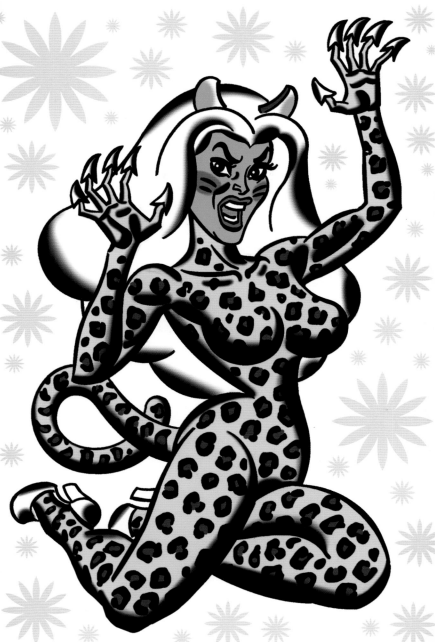

139

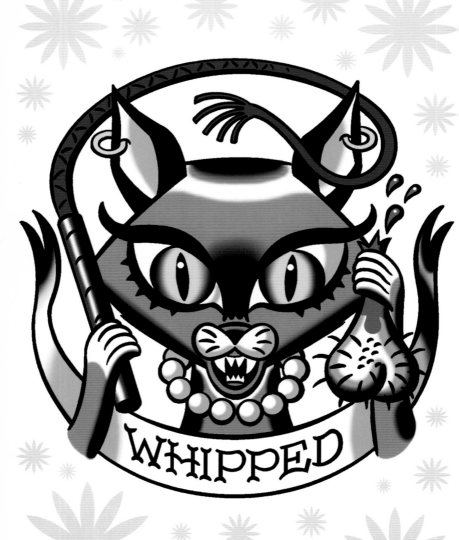

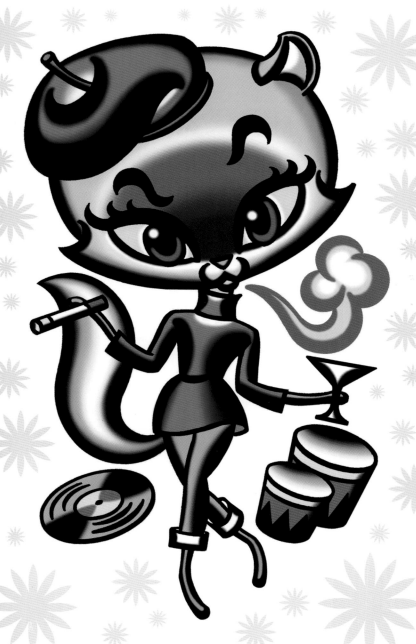

141

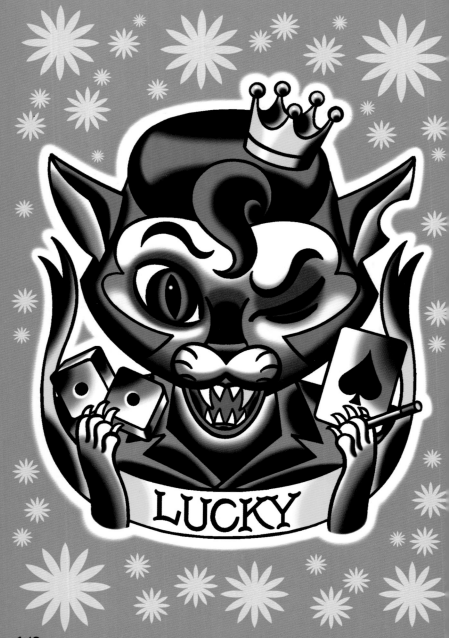

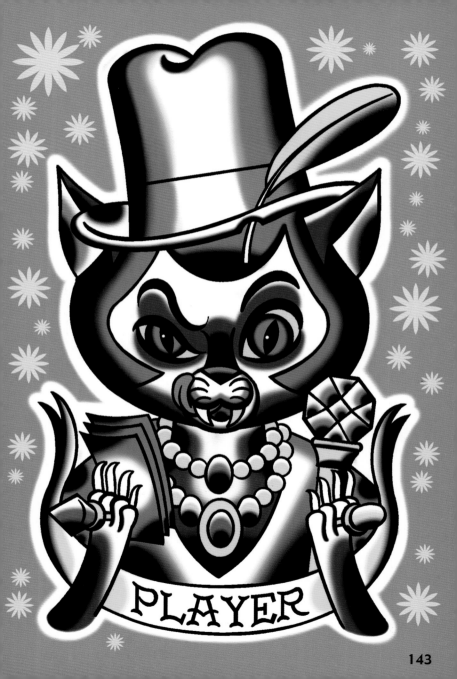

PLAYER

143

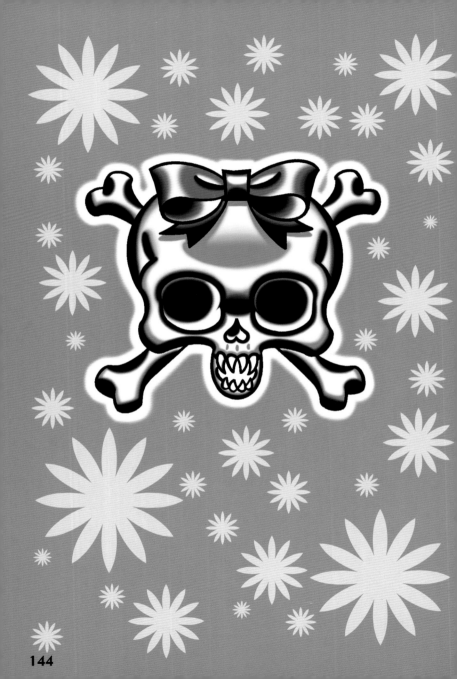

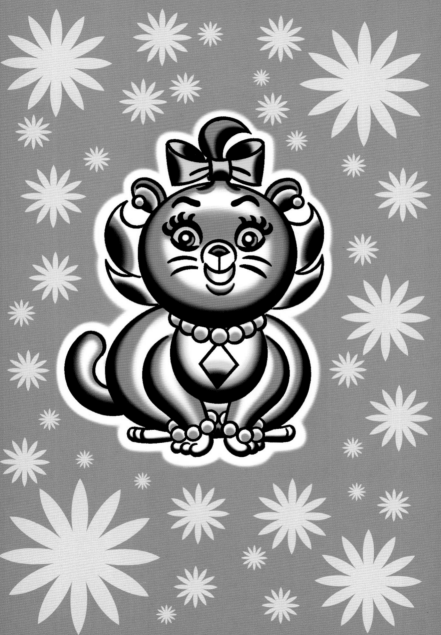

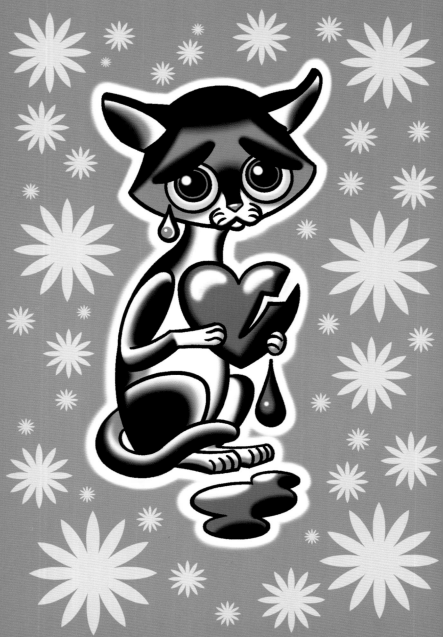

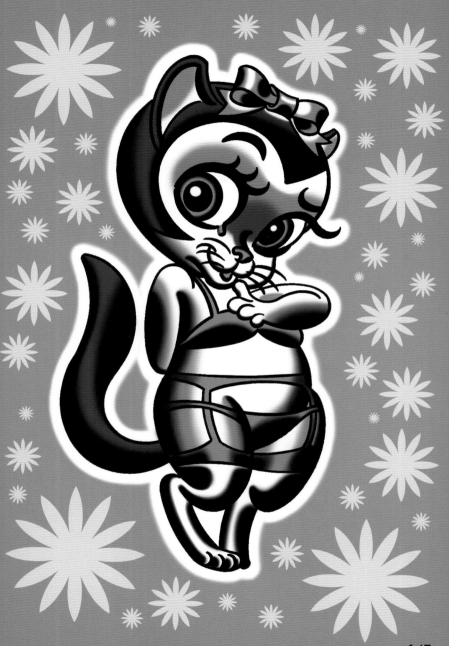

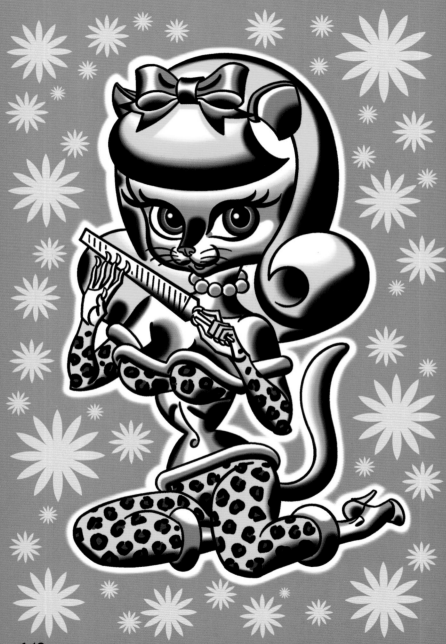

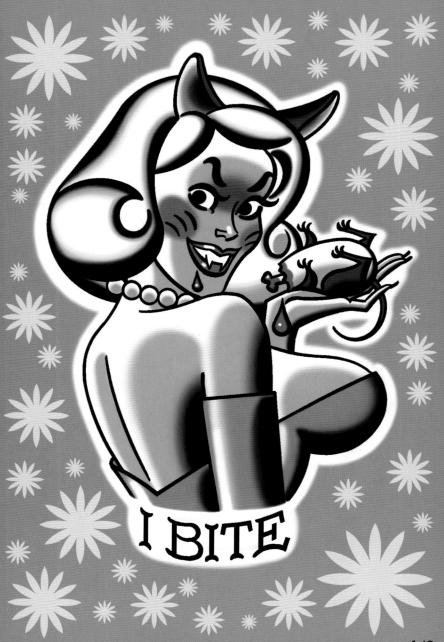

I BITE

149

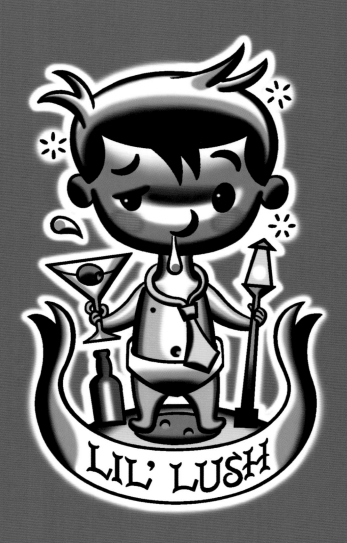

LIL' LUSH

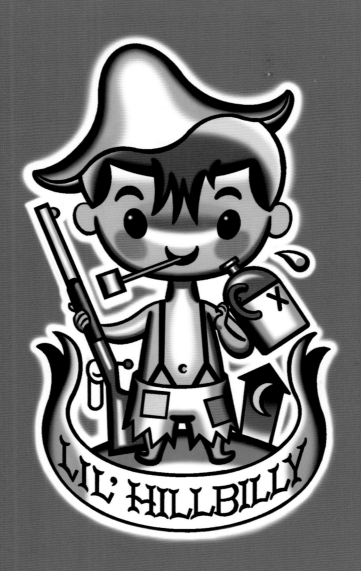

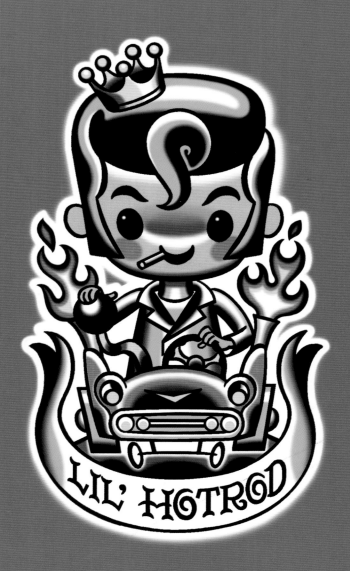

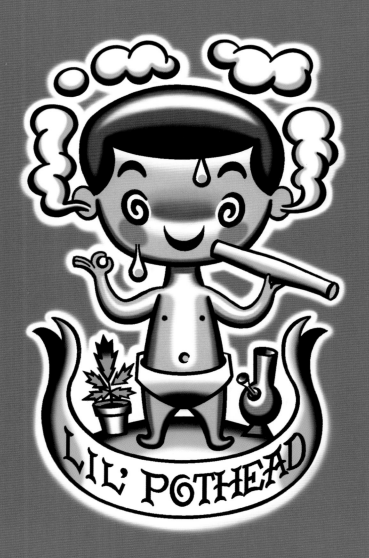

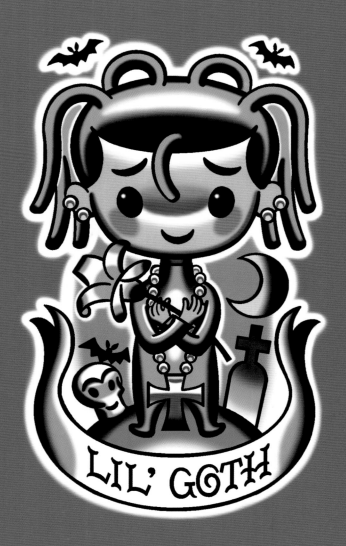

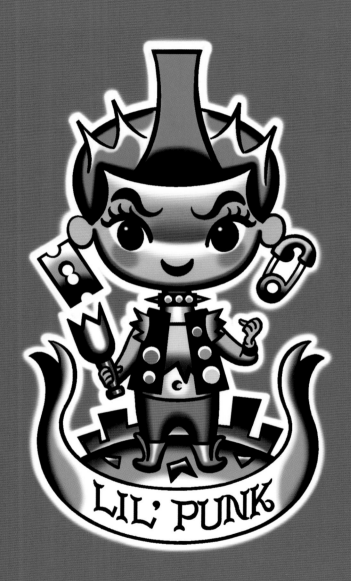

LIL' PUNK

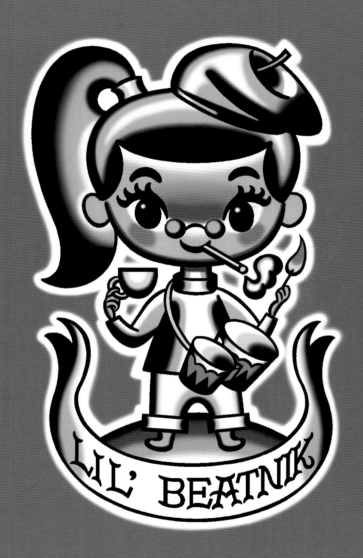

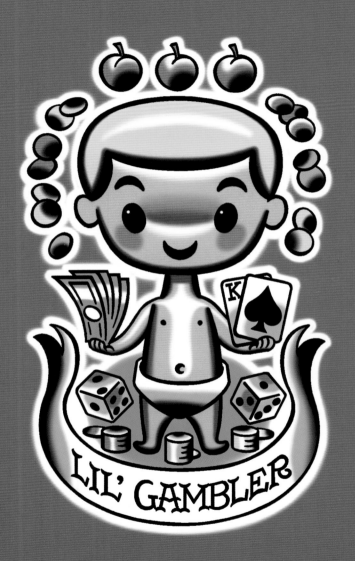

LIL' GAMBLER

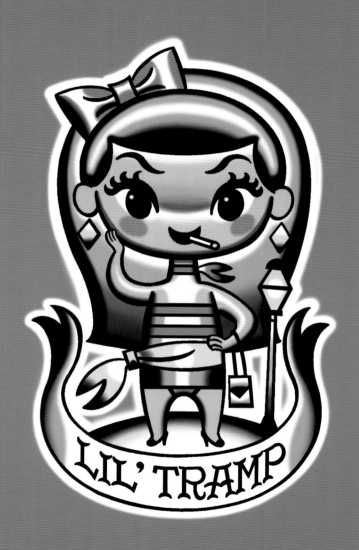

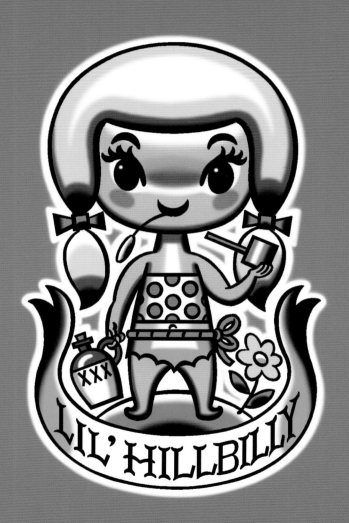

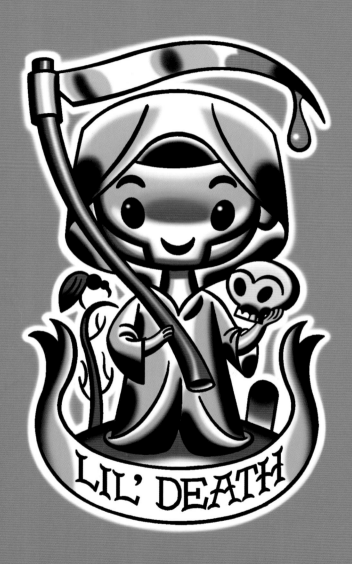

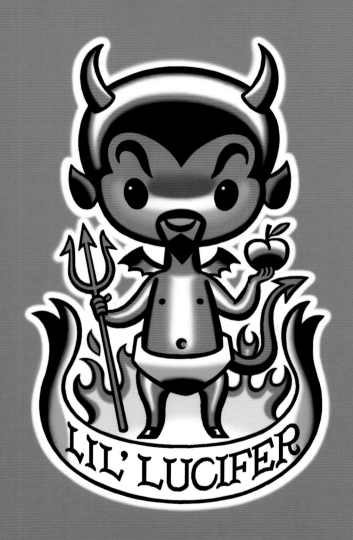

LIL' LUCIFER

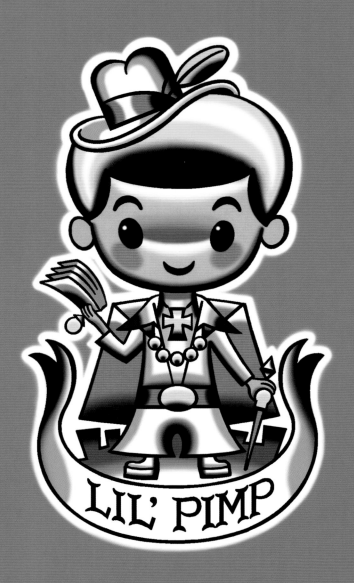

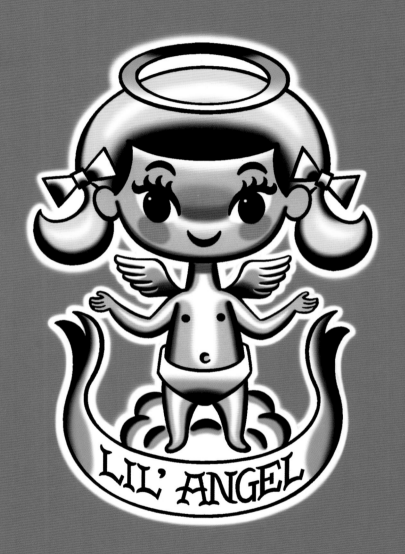

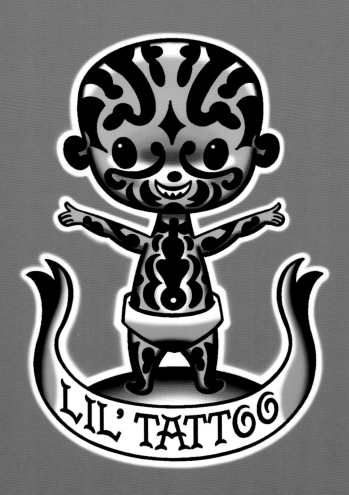

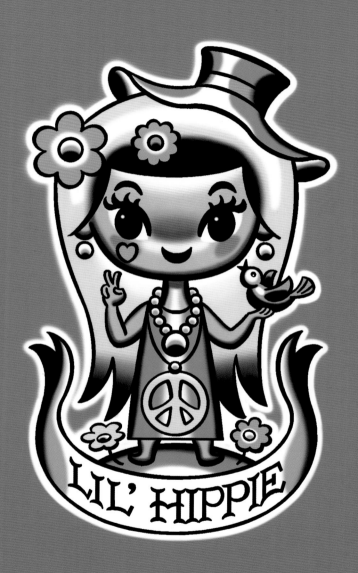

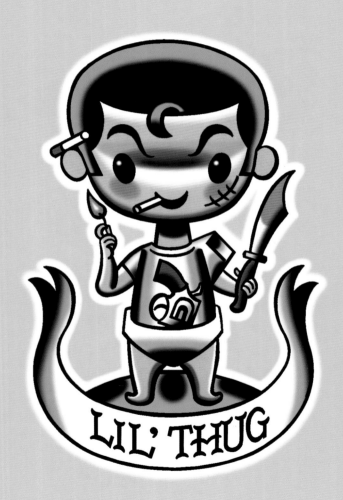

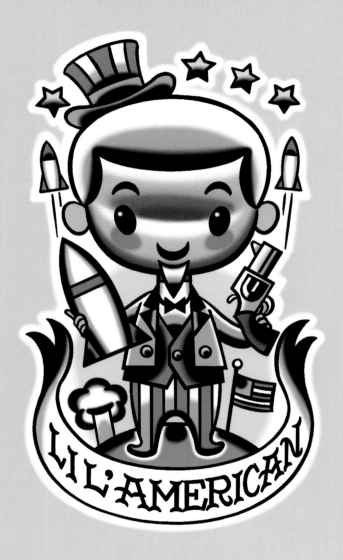

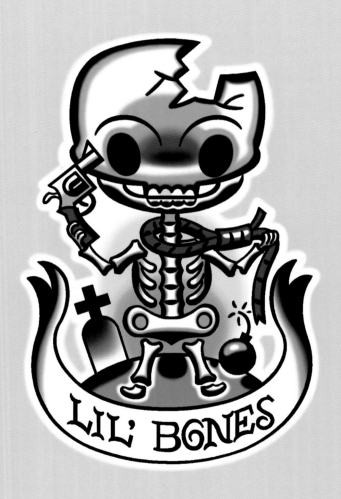

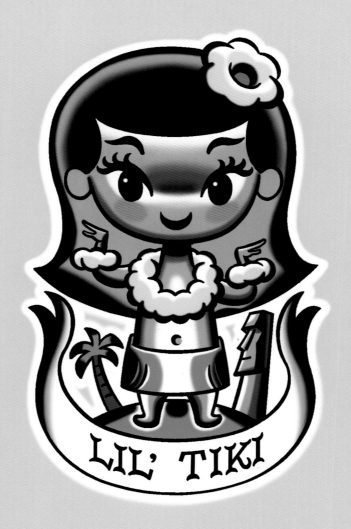

LIL' TIKI

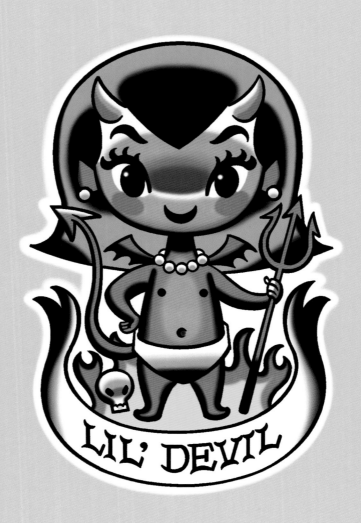

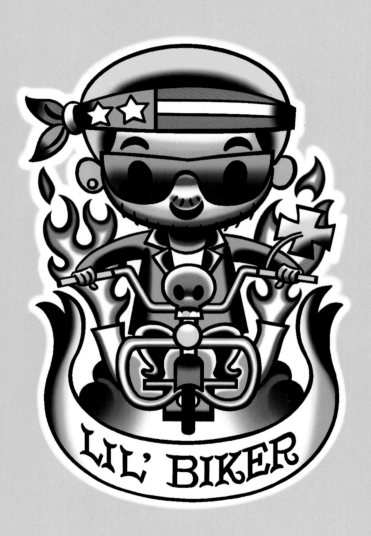

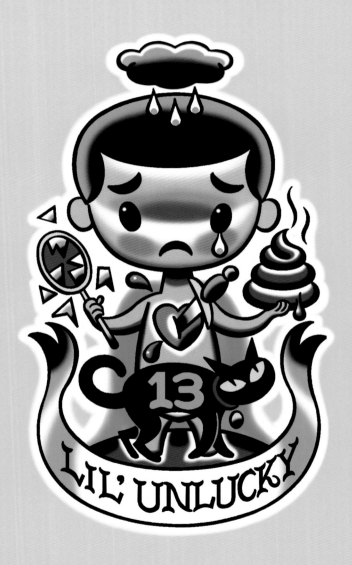

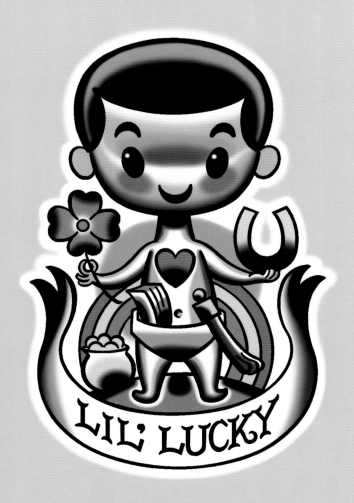

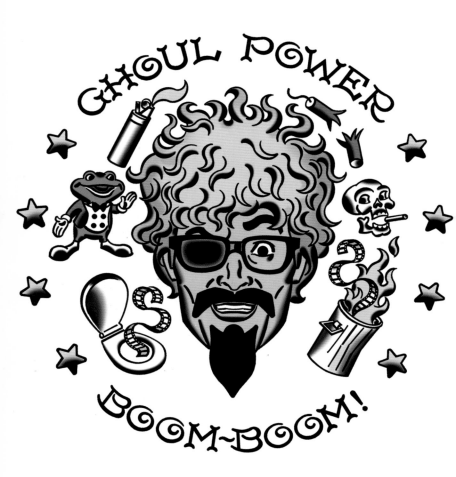

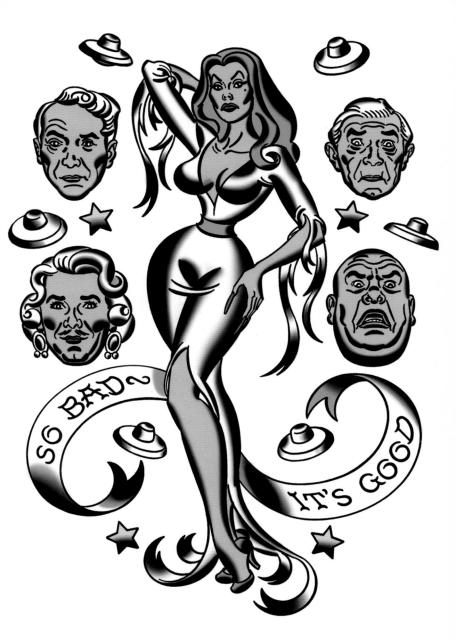

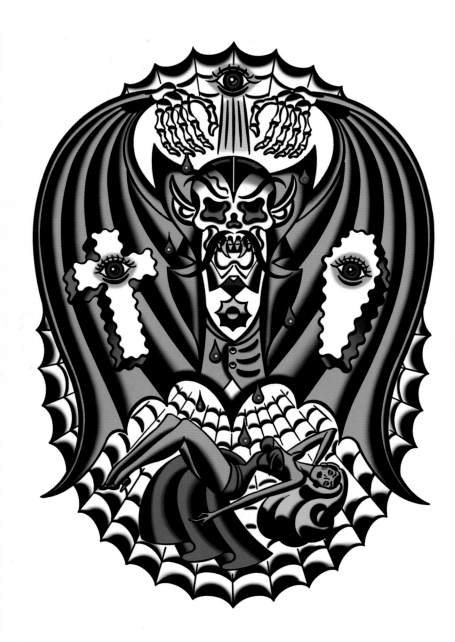

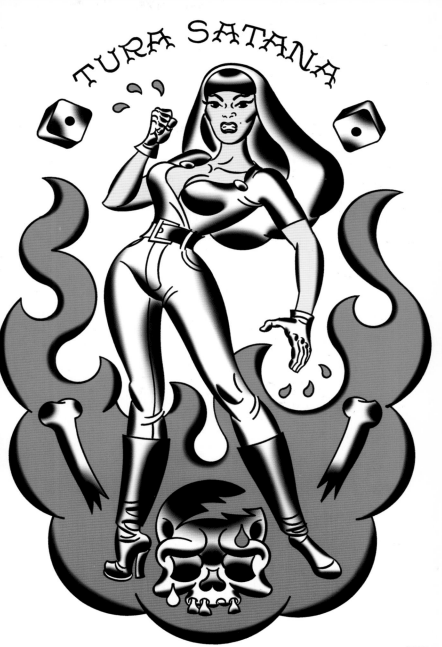

TURA SATANA

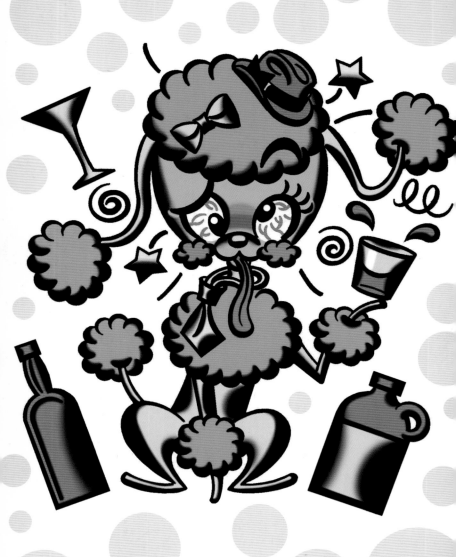

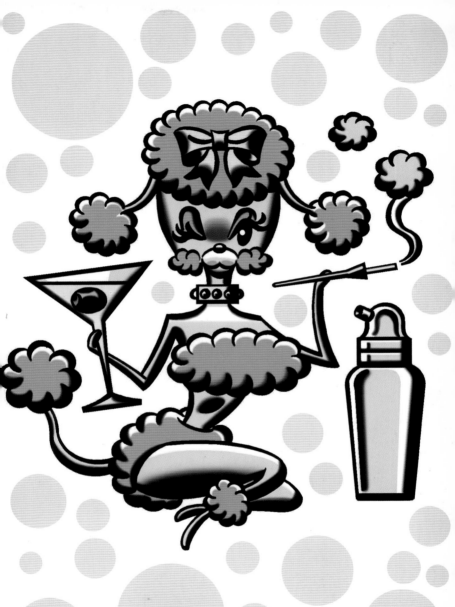

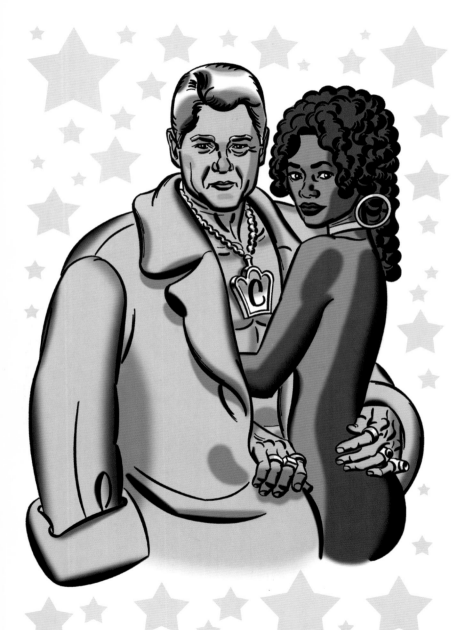

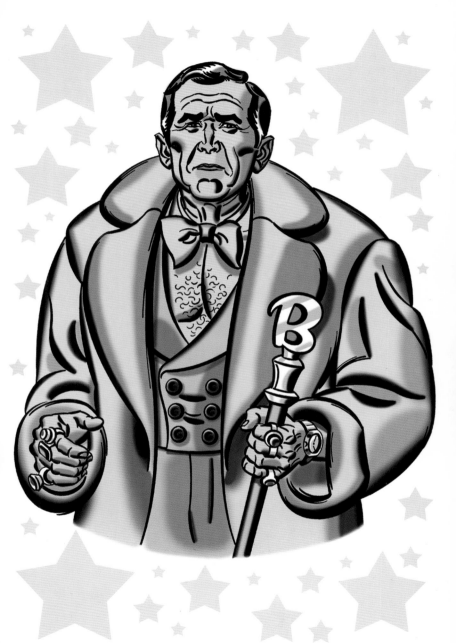

189

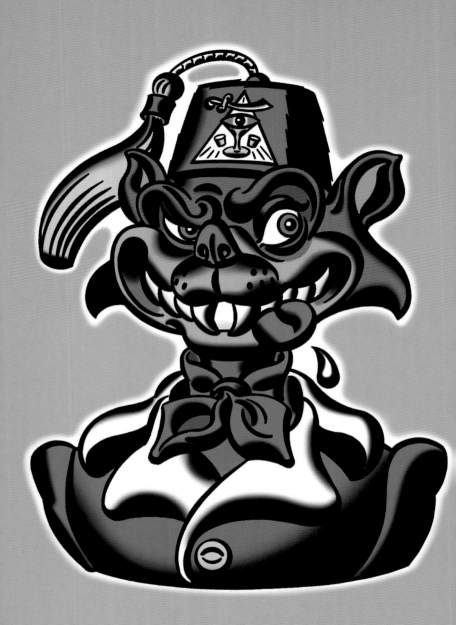

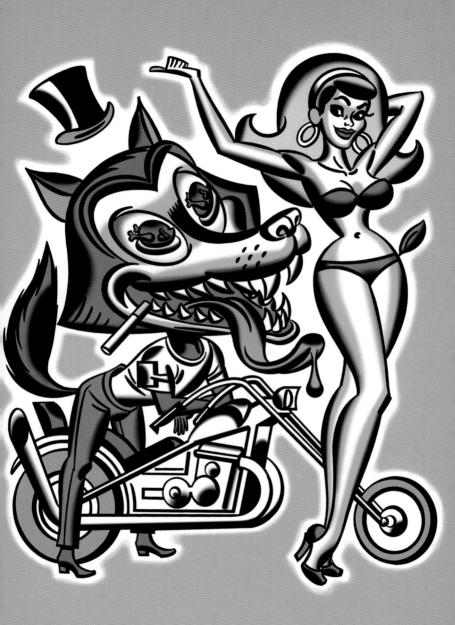

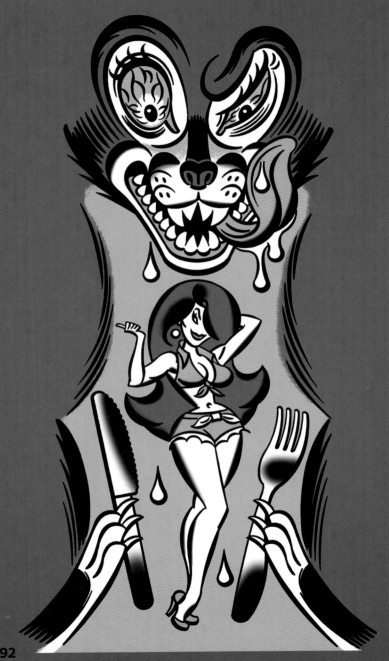

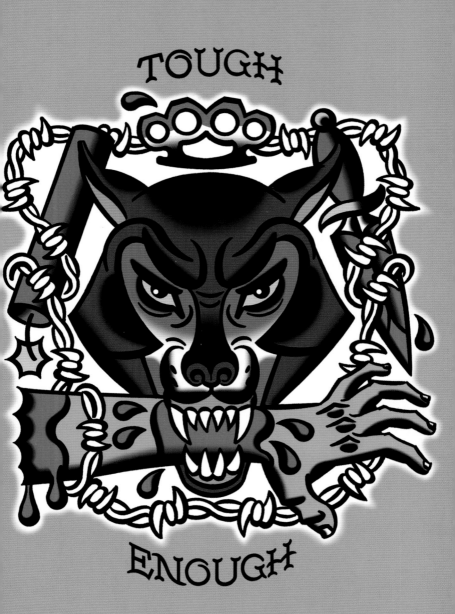

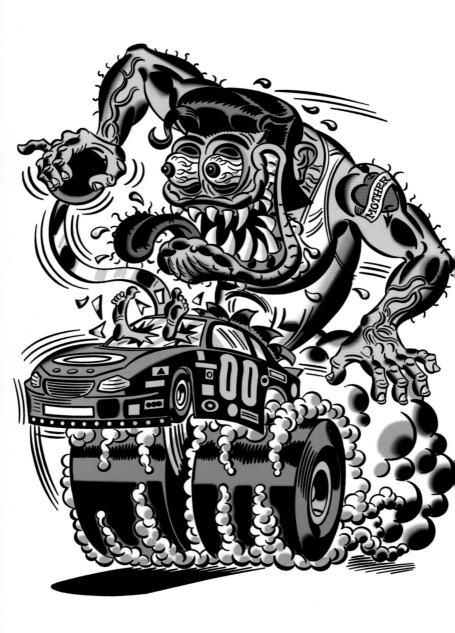

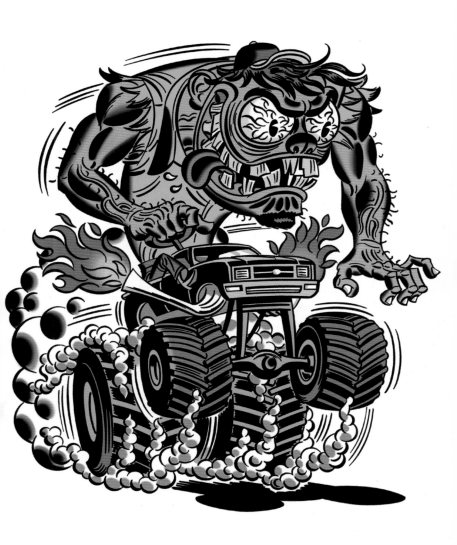

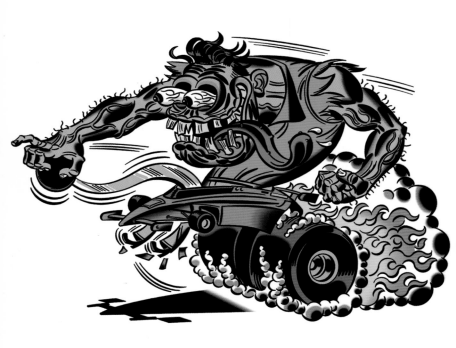

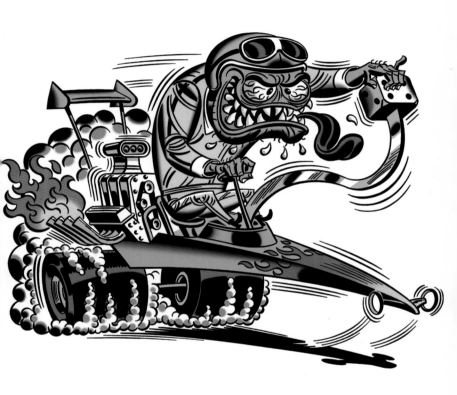

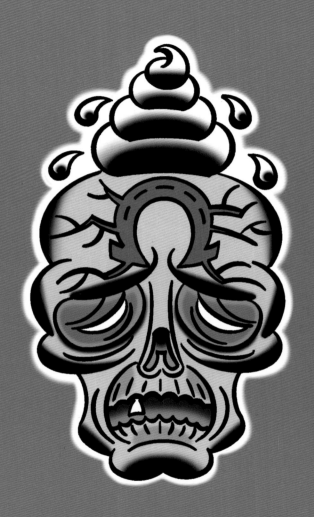

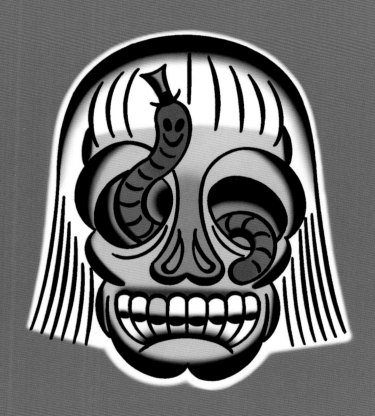

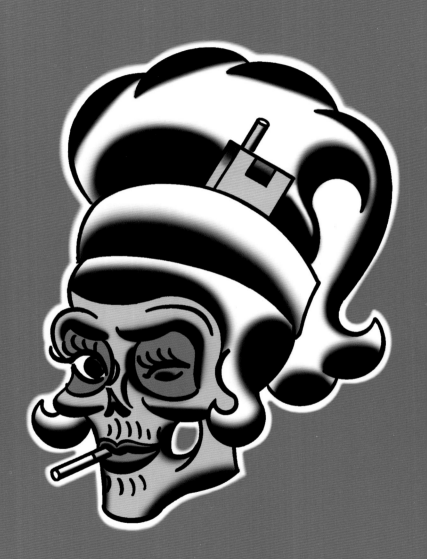

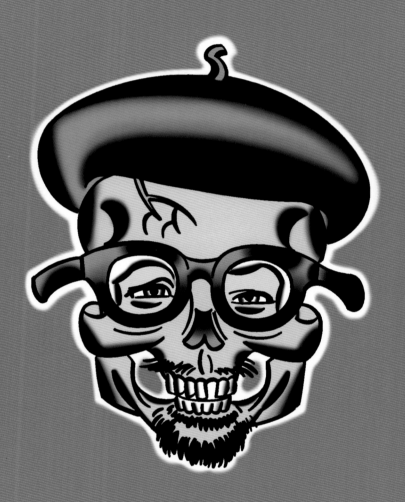

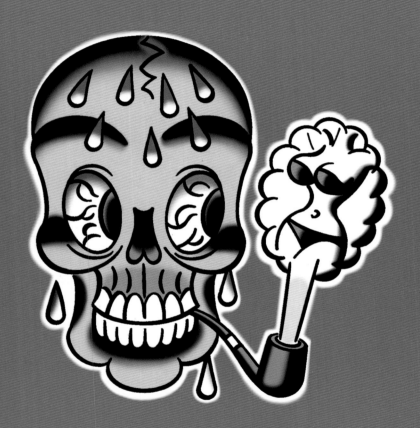

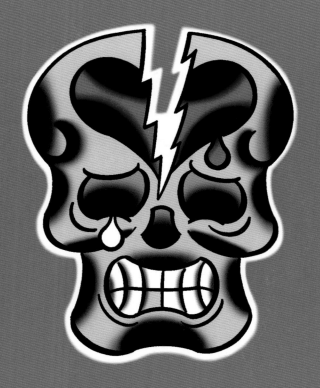

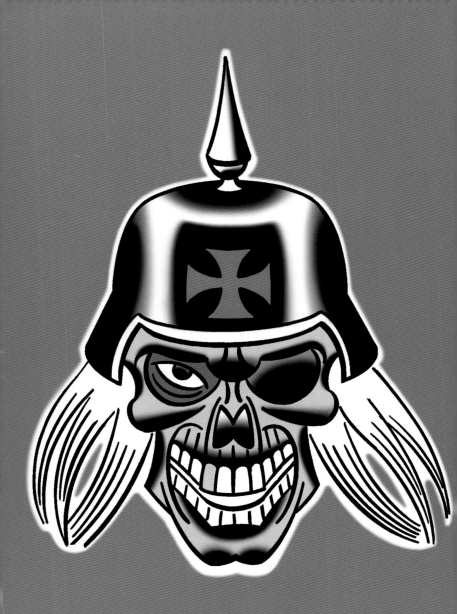

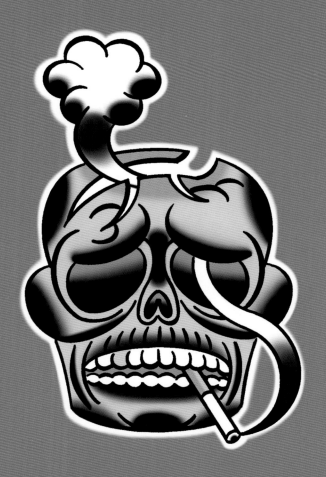

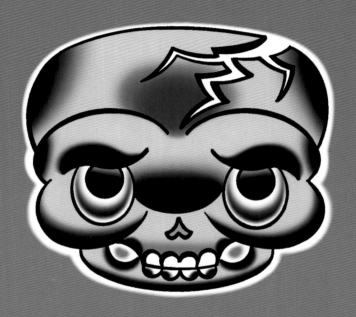

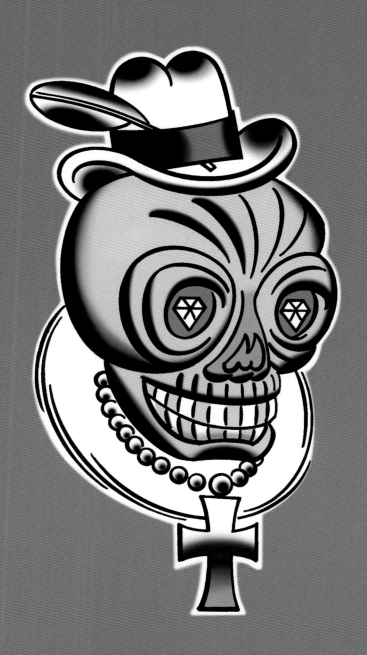

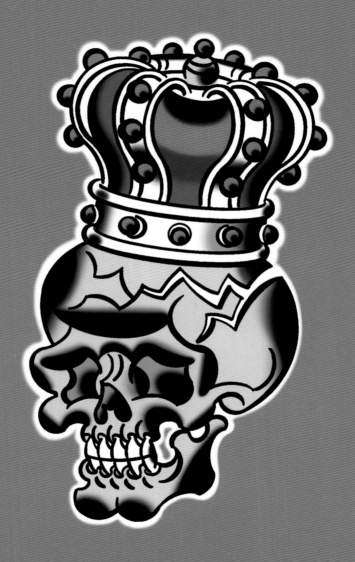

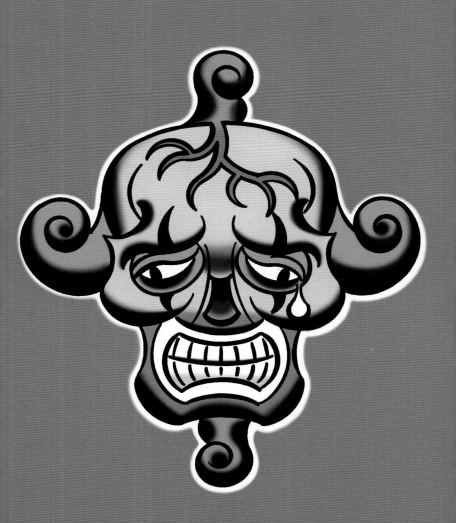

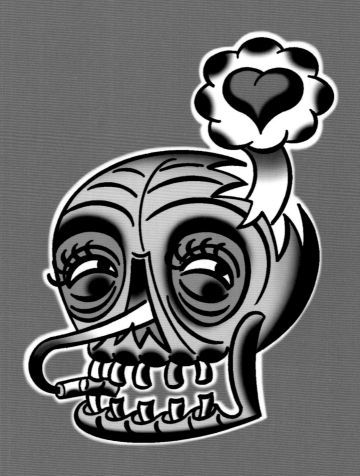

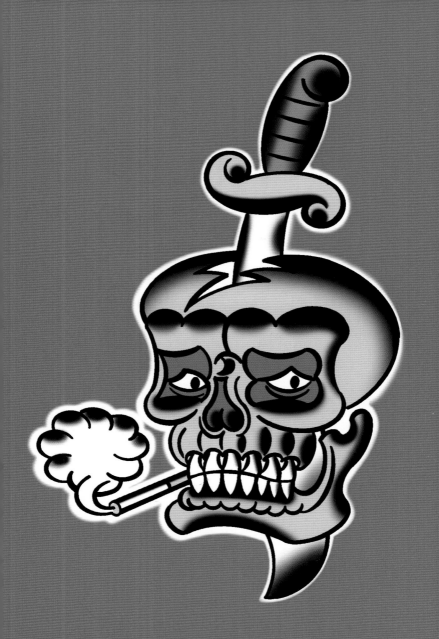

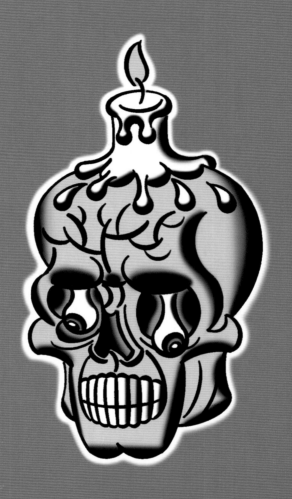

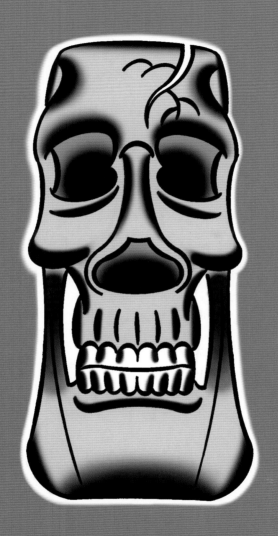

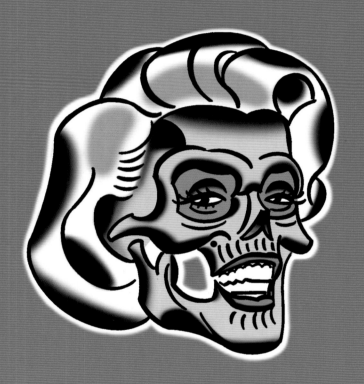

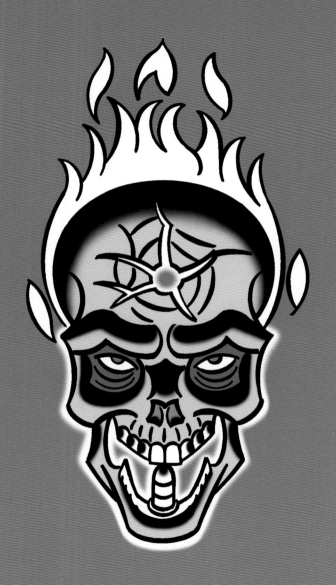

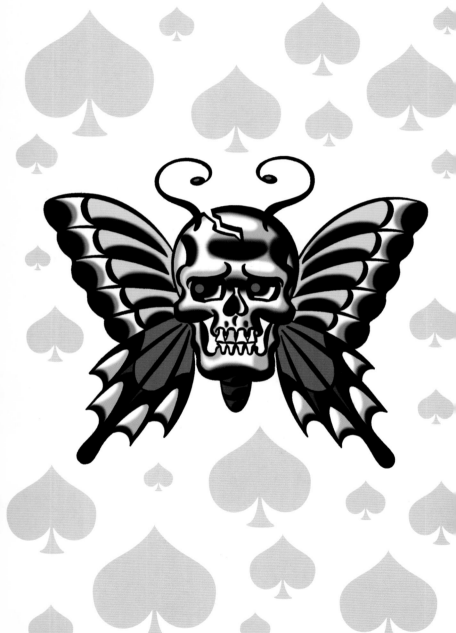

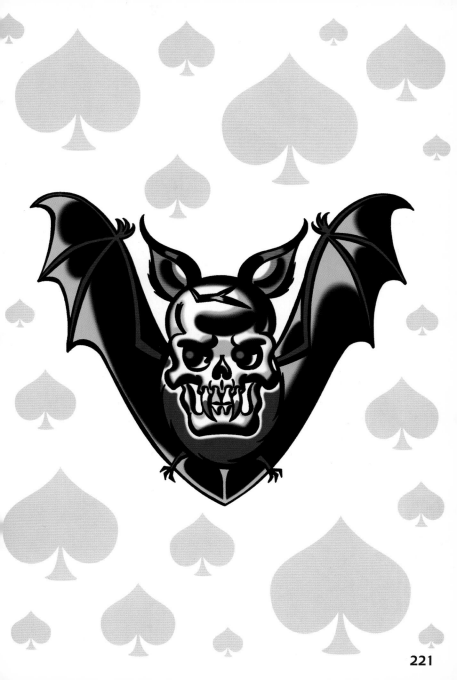

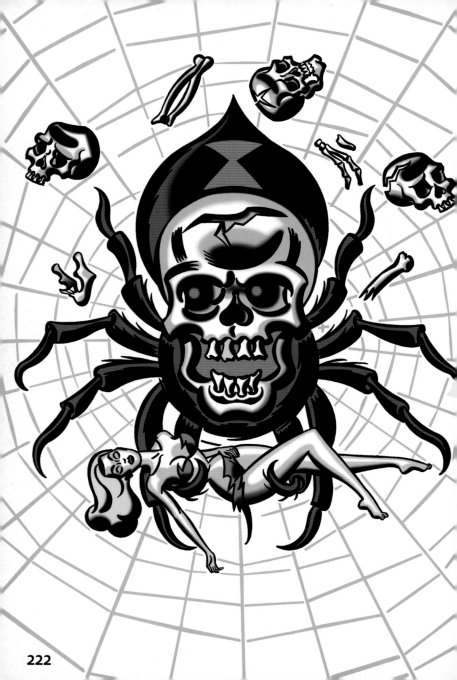

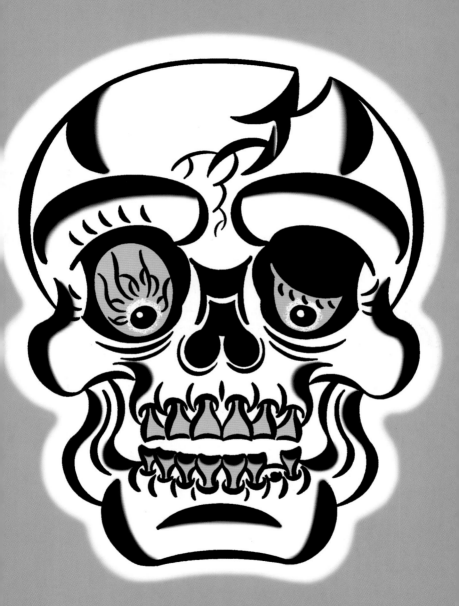

223

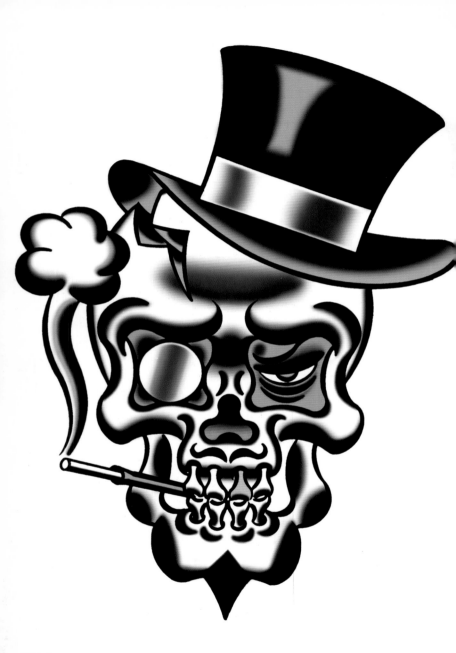

224

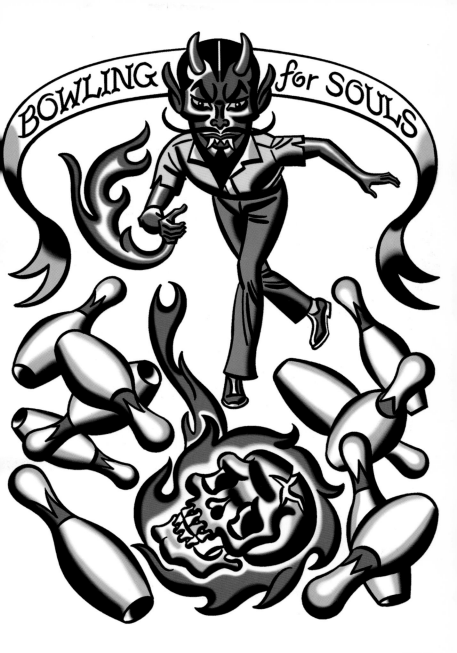

225

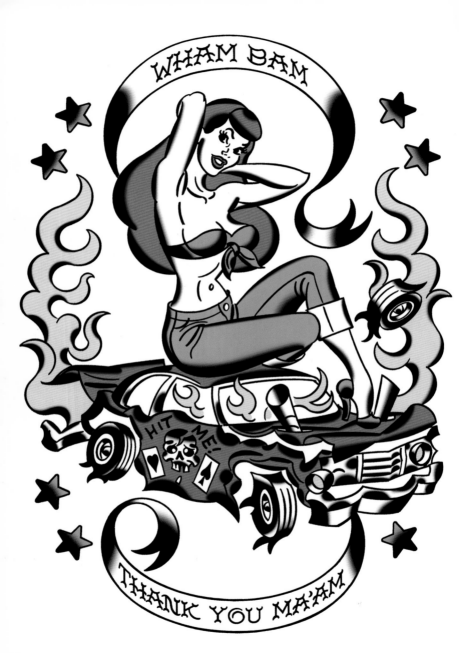

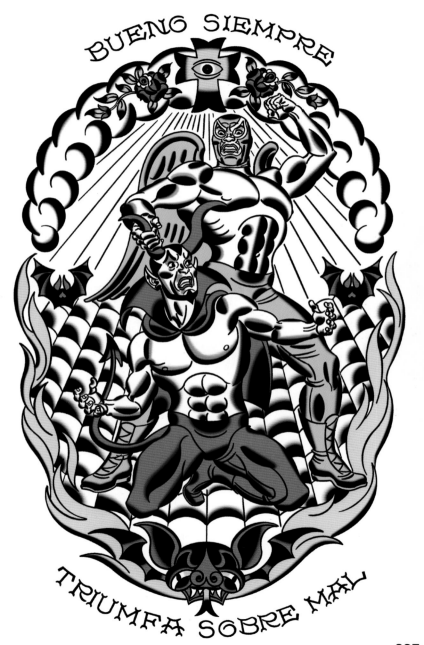

BUENO SIEMPRE

TRIUMFA SOBRE MAL

227

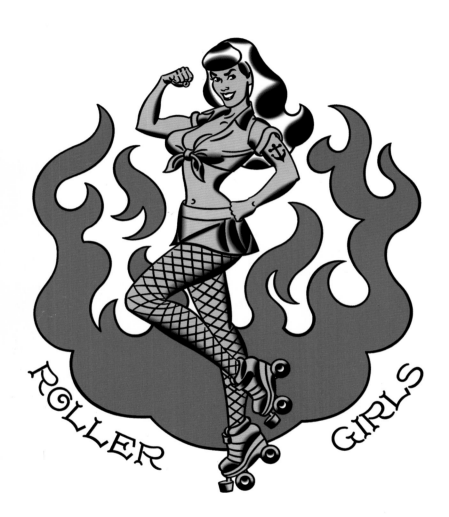

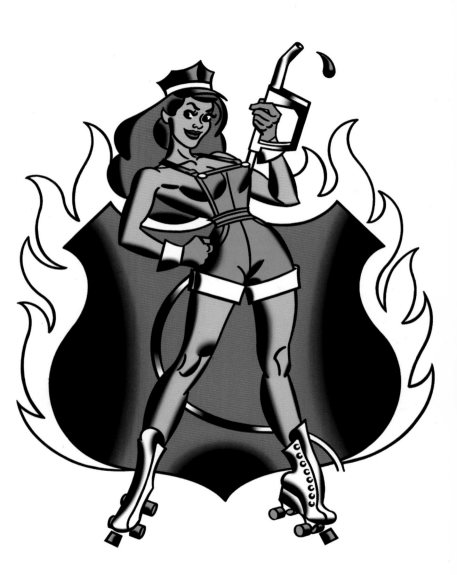

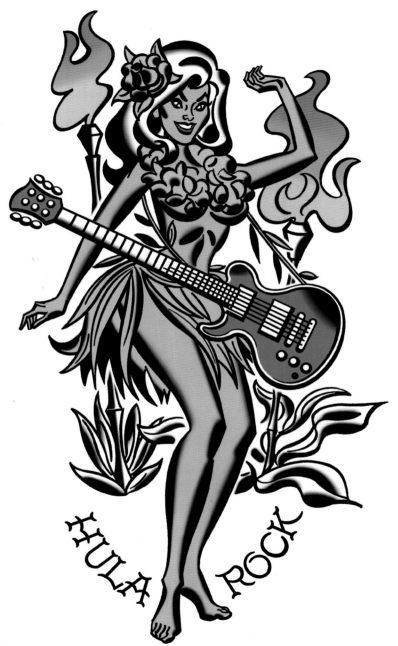

HULA ROCK

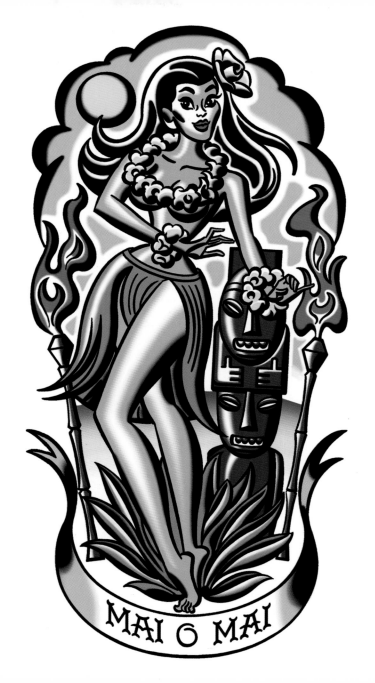

MAI Ö MAI

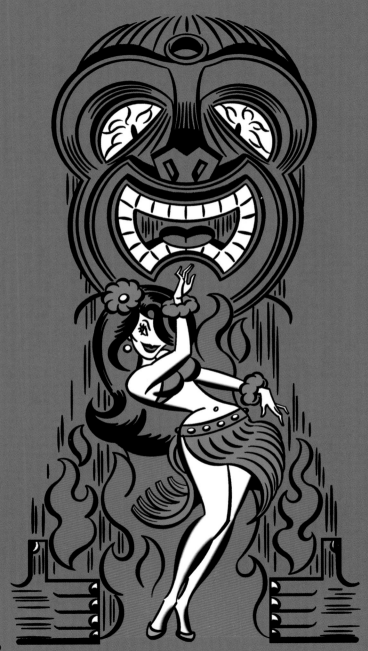

232

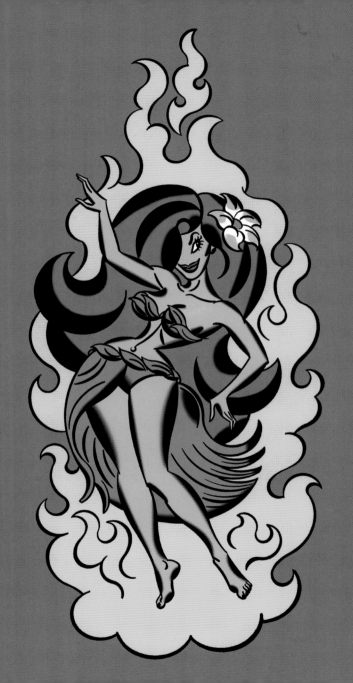

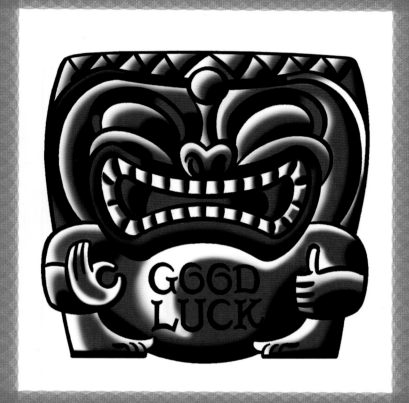

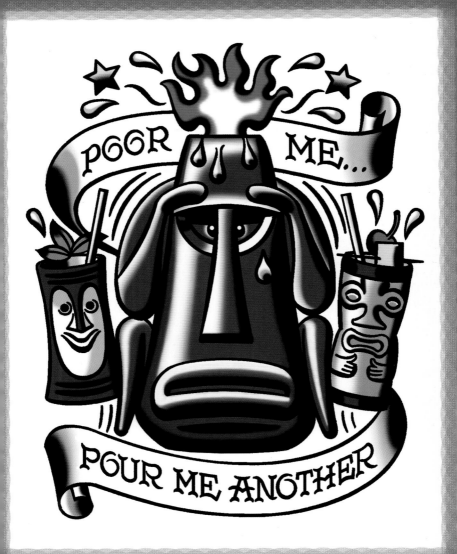

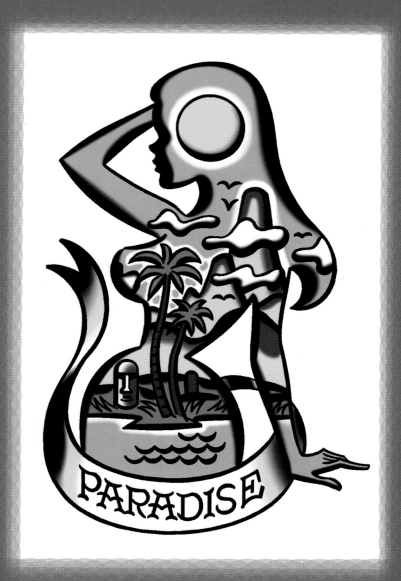

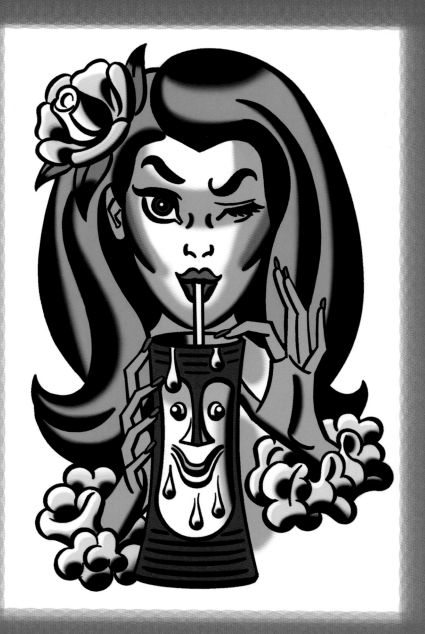

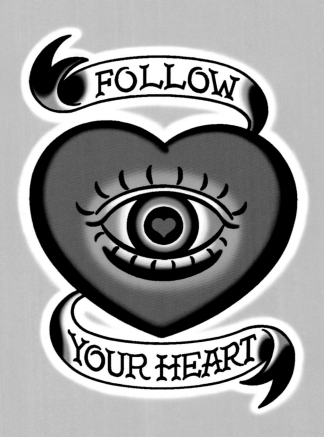

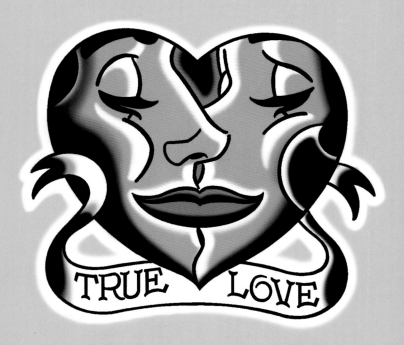

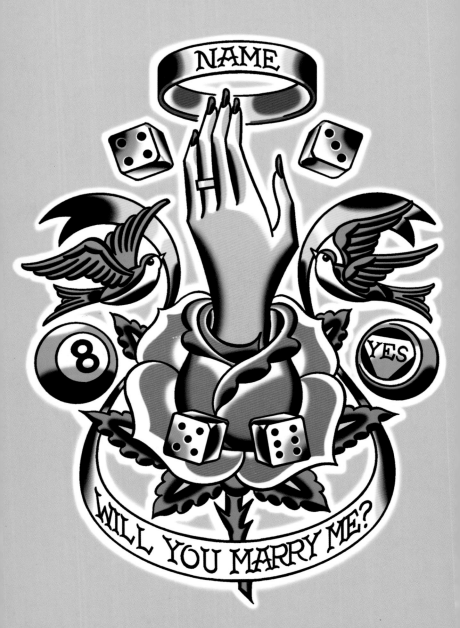

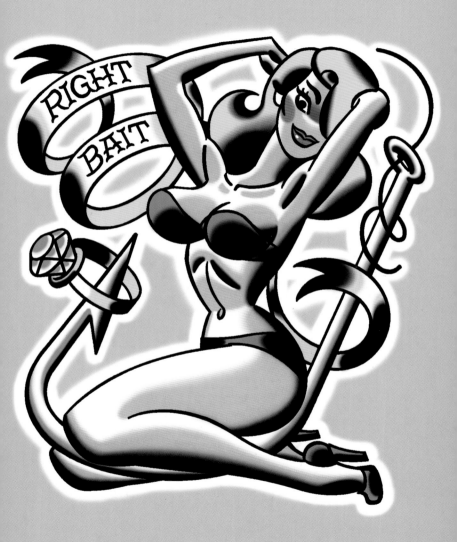

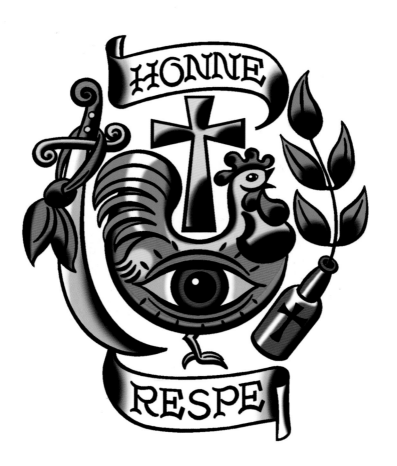

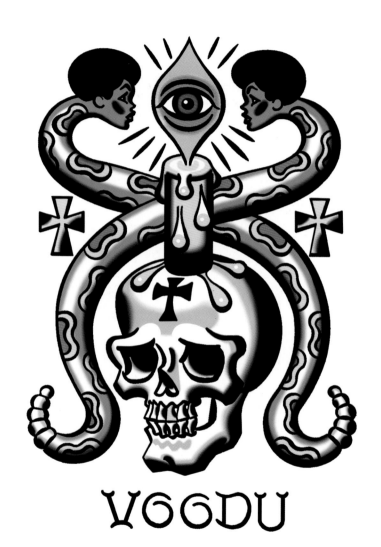

VOODU

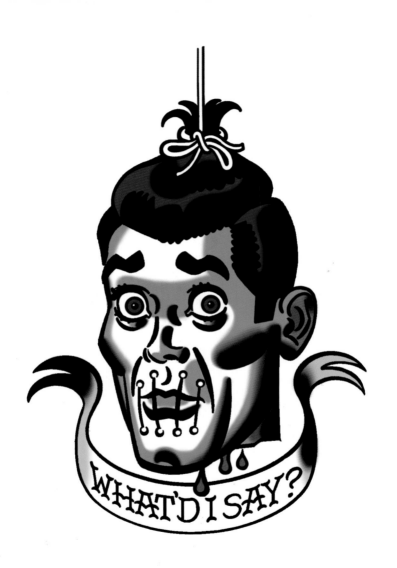

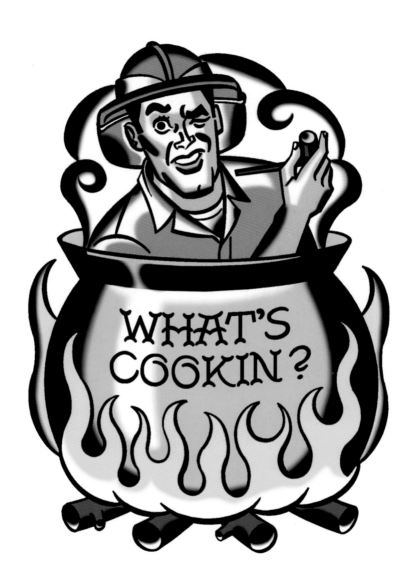

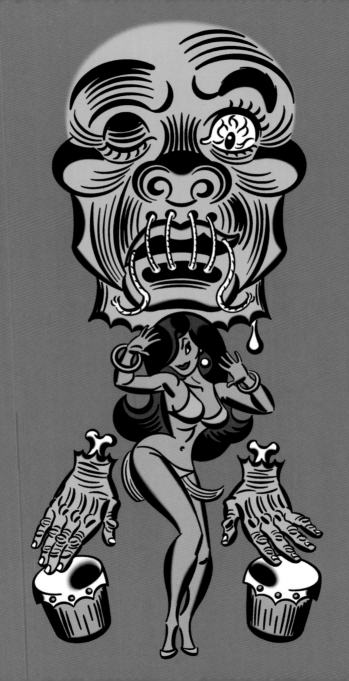

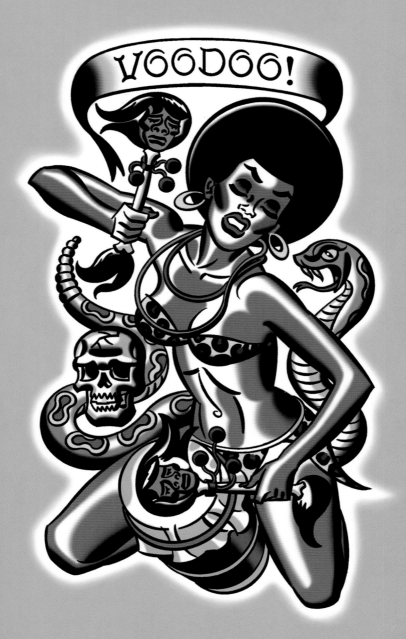

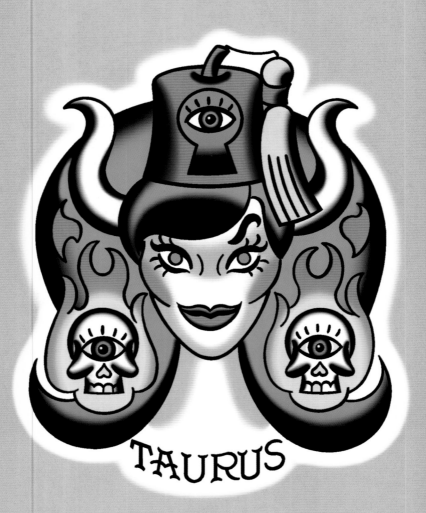

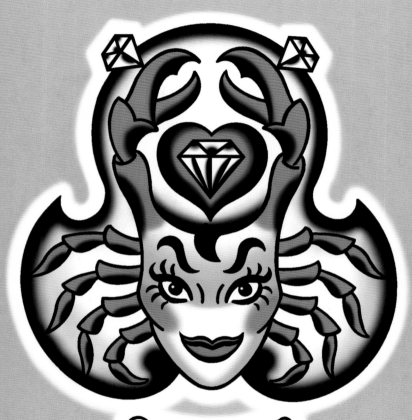

CANCER

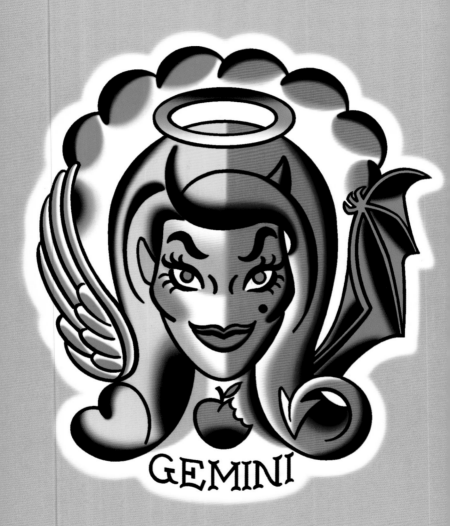

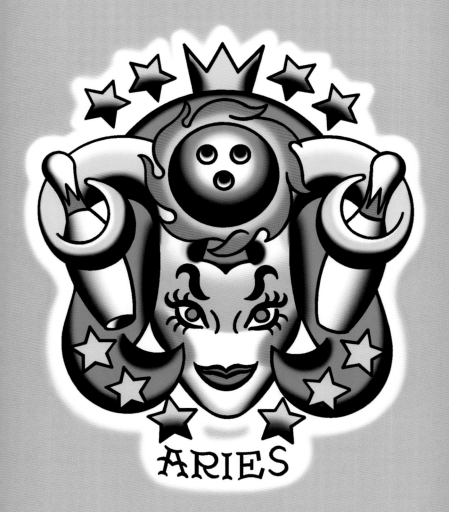

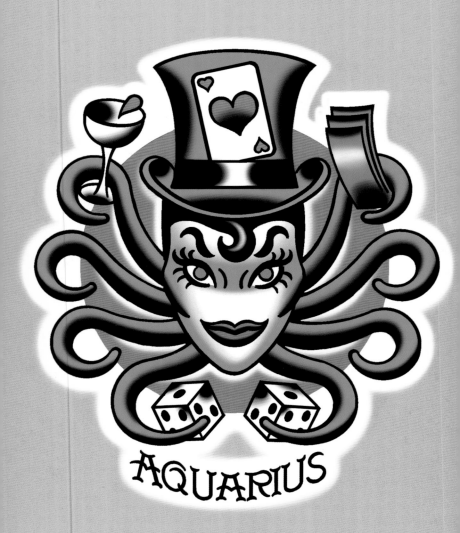

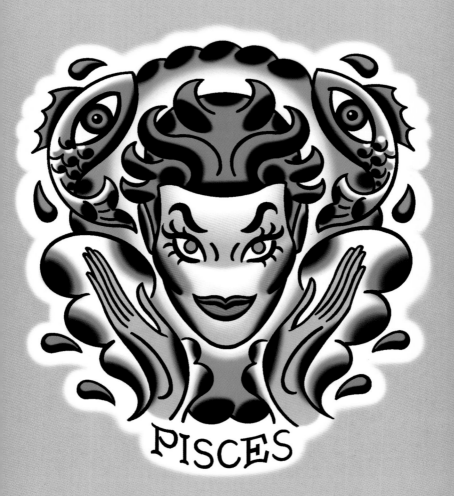

PISCES

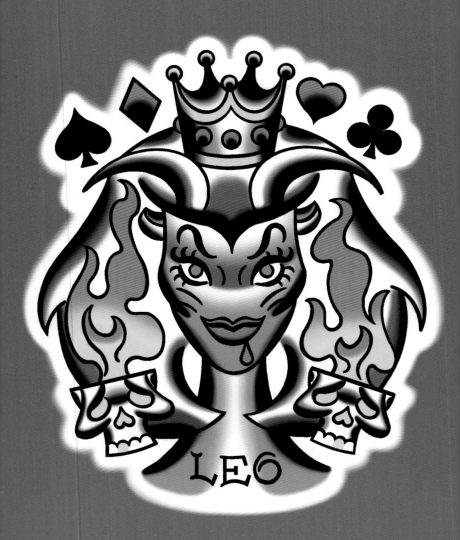

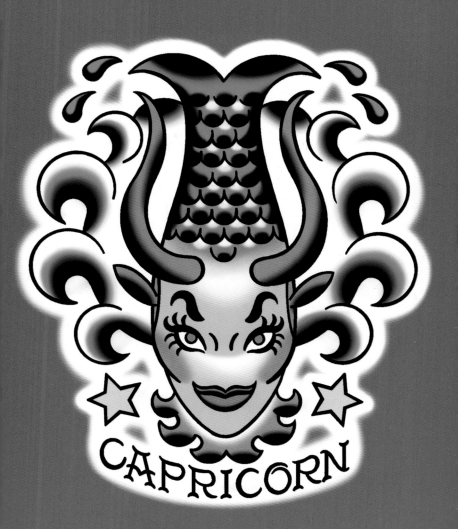

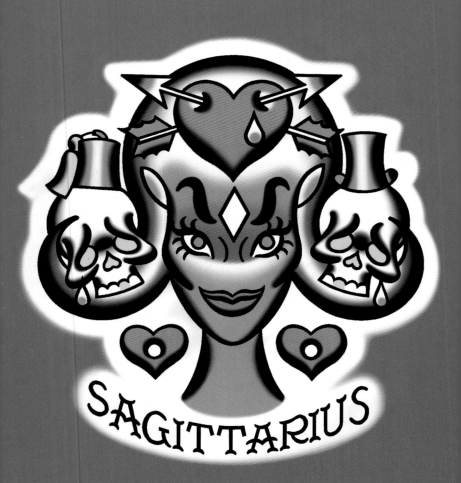

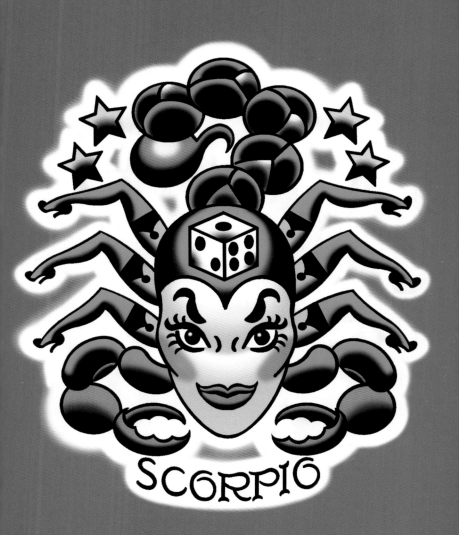

SCORPIO

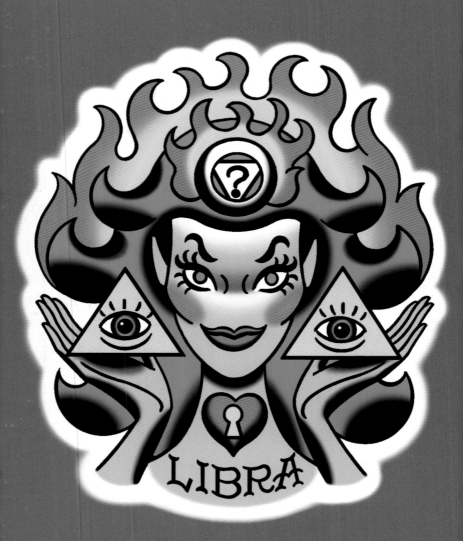

LIBRA

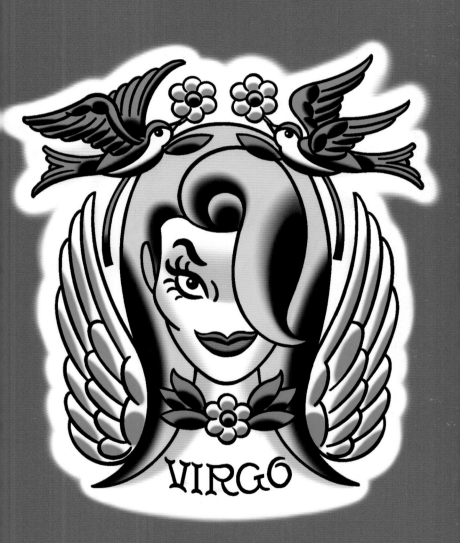

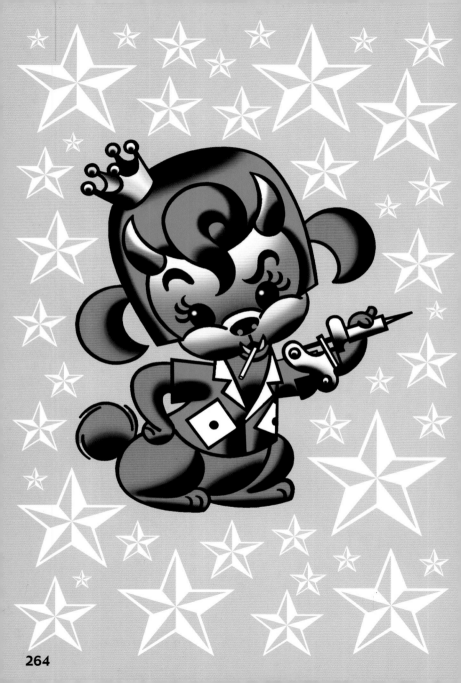

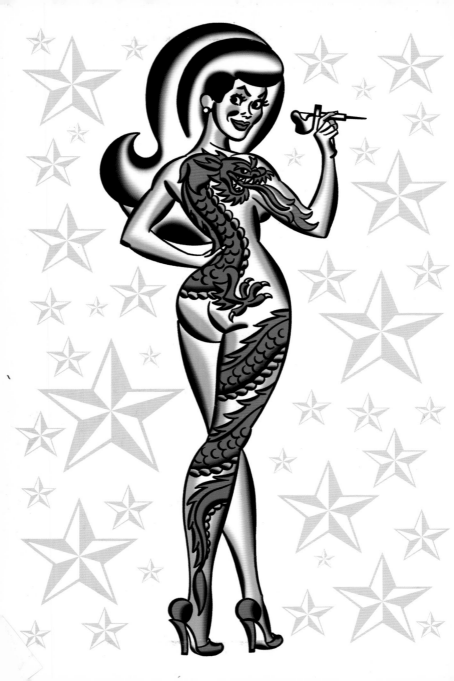